Best Works of
Aubrey Beardsley

Dover Publications, Inc.
New York

Best Works of Aubrey Beardsley, first published in 1990, is a new
collection of Beardsley's work, selected from *The Early Work of Aubrey
Beardsley* (revised edition, 1920) and *The Later Work of Aubrey Beardsley*
(revised edition, 1930), published by John Lane, The Bodley Head, London.
The photographs of Beardsley on page 4 are also from these two sources. The Introduction
and captions were prepared specially for the Dover edition by Thea Mohr.

DOVER *Pictorial Archive* SERIES

This book belongs to the Dover Pictorial Archive Series. You may use the designs and
illustrations for graphics and crafts applications, free and without special permission, provided
that you include no more than ten in the same publication or project. (For permission for
additional use, please write to Dover Publications, Inc., 31 East 2nd Street, Mineola, N.Y.
11501.)
However, republication or reproduction of any illustration by any other graphic service,
whether it be in a book or in any other design resource, is strictly prohibited.

Manufactured in the United States of America
Dover Publications, Inc.
31 East 2nd Street
Mineola, N.Y. 11501

Library of Congress Cataloging-in-Publication Data

Beardsley, Aubrey, 1872–1898.
 Best works of Aubrey Beardsley.
 p. cm.
 ISBN 0-486-26273-1
 1. Beardsley, Aubrey, 1872–1898—Catalogs. I. Title.
N6797.B425A4 1990
741.6′092—dc20 90-33318
 CIP

Introduction

AUBREY BEARDSLEY (1872–1898), a young, iconoclastic illustrator from Brighton with almost no formal training, was elevated by innovative publishers to positions of responsibility that enabled him to start an artistic revolution in London. Between 1893 and 1898, the main years of his short career, Beardsley's few mentors in publishing gave him the enormous assignments of illustrating full-length books and serving as art editor and principal illustrator for new magazines.

These publications demanded much artwork of him, so that his drawings were executed boldly and were sometimes unrelated to the texts they accompanied. Moreover, he was allowed a great deal of independence, and used these opportunities to introduce elements of blatant sensuality and morbidity. His drawings appeared all over London, and their appearance within the same covers as the work of the outstanding writers and artists of the Aesthetic movement of the period led him to be associated with that influential circle almost immediately.

Beardsley's free hand was unwelcome to the unprepared conservative public of his time, but in the long run was recognized as that of a revolutionary genius. The purity of his use of black and white—sharp, clean line and pure black or white masses with no modeling or shading—was completely original in the illustration of his day; and the freedom and originality with which he associated one theme or motif with another in his compositions is considered remarkable even to today's unshockable art lovers.

Beardsley received his first major commission as an illustrator in 1893, when still only twenty years old: to illustrate *Le Morte Darthur* for J. M. Dent and Co. This proved to be a tremendous job for which he executed hundreds of drawings. Though executed in a fairly conservative medieval style reminiscent of Edward Burne-Jones, his borders, chapter heads and other page embellishments were seasoned with the appearance of winged figures, satyrs and other unexplained elements; and his full-page drawings imaginatively interpreted the book's characters and scenes. With work from this huge project in his portfolio, the young artist attracted the editors of various London magazines. In the celebrated arts magazine *The Studio,* his work first appeared with a special introduction, "A New Illustrator," written by the well-established American illustrator Joseph Pennell. It was still 1893 when John Lane, of the publishing firm The Bodley Head, commissioned Beardsley to illustrate Oscar Wilde's *Salome,* to be published the following year. In illustrating this erotic play about the execution of John the Baptist by Herod Antipas, Beardsley took great liberties himself (it is often said that he sought to ridicule the play), producing sensual and horrifying images that were sometimes completely out of keeping with the text. Stylistically, these particular illustrations appear to reveal the influence of Japanese art, which Beardsley indeed admitted to emulating in some of his work. It is often noted that a visit early in his career to James McNeill Whistler's Peacock Room, which contained a collection of Japanese prints, made a strong impression upon him.

In 1894 John Lane appointed Beardsley art editor and chief illustrator of *The Yellow Book,* a new arts magazine that would also contain the work of authors such as Henry James, William Butler Yeats and Max Beerbohm and of such illustrators as Sir Frederic Leighton and Walter Sickert. Simultaneously with his *Yellow Book* career, Beardsley designed covers for the Keynotes series, an assortment of novels with cover designs of very similar format, published by John Lane.

After illustrating four issues of *The Yellow Book,* Beardsley was dismissed in 1895, at the insistence of readers who mistakenly associated him with the scandals then surrounding Oscar Wilde. This dismissal was a painful blow, removing him from what had become the seat of his career—a position of distinction, in a special circle of prominent London artists associated with the magazine. Soon afterward, however, he found new advocacy in Leonard Smithers, another book and magazine publisher (original publisher of Wilde's *The Importance of Being Earnest*). Beardsley was appointed art editor of *The Savoy,* a new arts magazine published by Smithers. Havelock Ellis, George Bernard Shaw, Yeats and Beerbohm were among the many outstanding London writers and illustrators featured in its pages. Beardsley illustrated eight issues of *The Savoy* between 1895 and 1896. In addition to artwork, he contributed his own writings, including the poems "The Three Musicians" and "The Ballad of a Barber," a translation of Catullus' "Carmen CI" and an unfinished

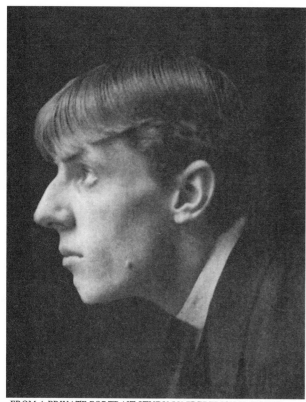

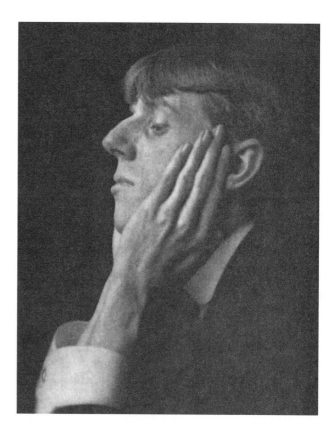

FROM A PRIVATE PORTRAIT STUDY BY FREDERICK H. EVANS

novel titled *Under the Hill* (an expurgated version of another novel he never finished, *The Story of Venus and Tannhäuser*). These writings were accompanied, naturally, by his own illustrations.

Among the books Beardsley illustrated for Smithers was Alexander Pope's *The Rape of the Lock,* which was published in 1896. The famous drawings he executed for this book are considered to be lively and astute interpretations of Pope's satire, and are unsurpassed as examples of Beardsley's fine line work. While he was preparing drawings for *The Rape of the Lock,* Beardsley also decided to illustrate Aristophanes' *Lysistrata.* Smithers published an English translation of the text with his drawings in a limited edition. The illustrator's last great drawings took literature for their themes, such as his illustrations for *The Forty Thieves,* drawn in 1897; and those for Ben Jonson's *Volpone,* published in 1898 by Smithers. Aubrey Beardsley died of tuberculosis in 1898, at the age of 25.

Beardsley's style of illustration was highly original. He was brought into publication raw, with less than a year of formal training. The content of his drawings must have come mainly from his own young intellect and limited experience—and this fact makes the complexity of his compositions, and the variety of different themes therein, most impressive. Literature was a personal love that dominated the themes of his art. For many of his drawings of characters or scenes from well-known literature that were not published in books, he found outlets in the magazines he edited; and those that went unpublished after his death found their way into collections of his work compiled by his former publishers.

The present Dover collection draws upon all the important sources of Beardsley's work mentioned above—books and magazines from 1893 to 1898, the years of his career in London. To round out this selection of the most important works from his professional repertoire, charming designs for posters, bookplates, invitation cards, catalogue covers and other peripheral projects have also been included. It is hoped not only that readers will enjoy this collection for its comprehensive range of Beardsley's work, but also that today's artists, taking advantage of the fact that these works have been republished from public domain sources, will incorporate these incomparable designs into their own creative projects.

List of Illustrations

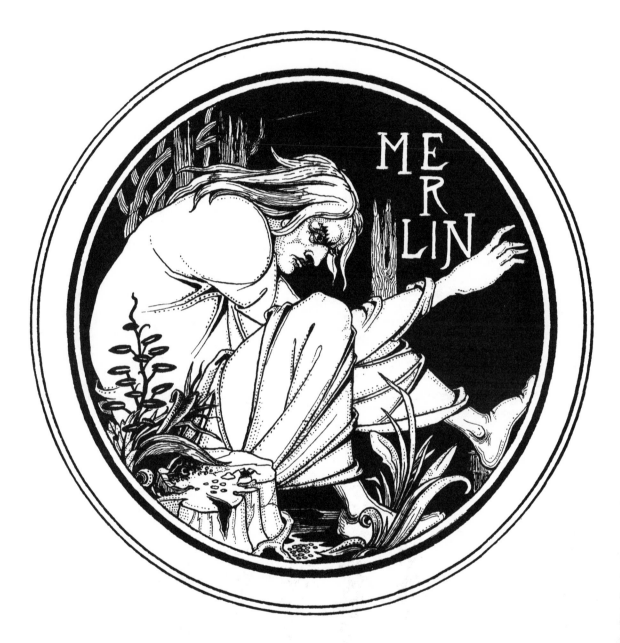

"Merlin." Roundel on contents-page verso of *Le Morte Darthur,* Vol. 1, published by J. M. Dent & Co., London, 1893.

Headpiece from title pages of Vols. 1 and 2 of *Le Morte Darthur.*

Chapter heads from *Le Morte Darthur.*

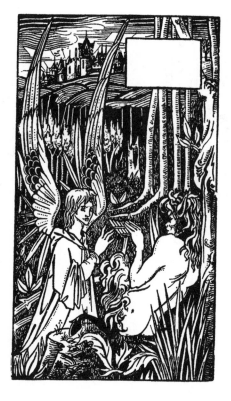 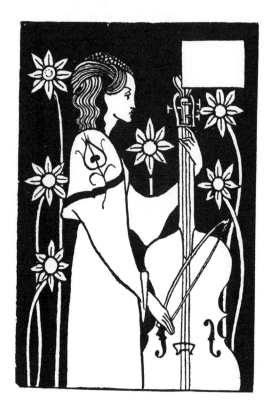

Chapter heads from *Le Morte Darthur.*

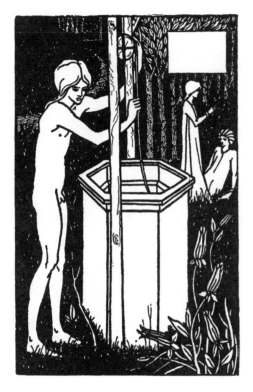

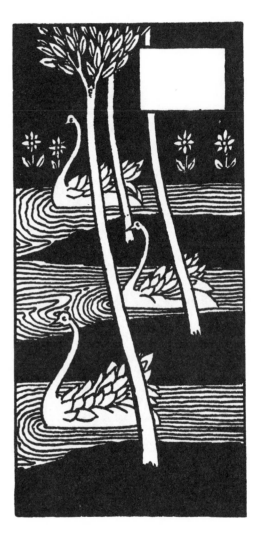

Chapter heads from *Le Morte Darthur*.

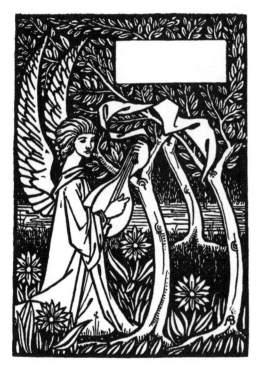 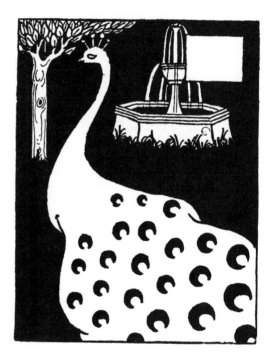

Chapter heads from *Le Morte Darthur.*

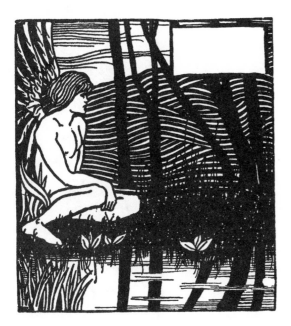

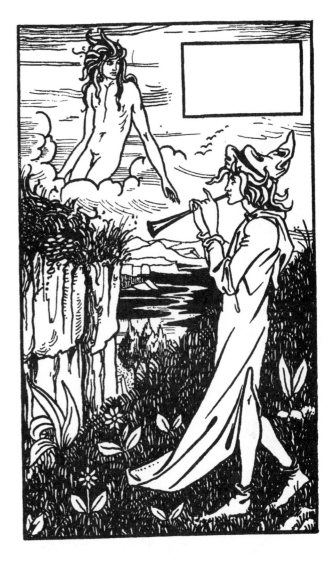

Chapter heads from *Le Morte Darthur.*

Border design from Book II, Chapter I of *Le Morte Darthur.*

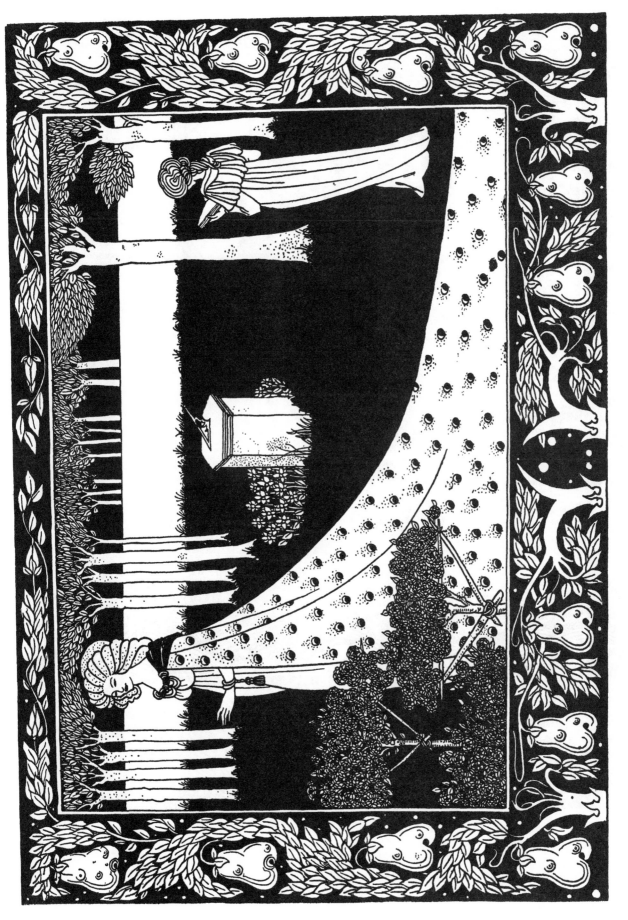

"La Beale Isoud at Joyous Gard," from Book X,
Chapter LII of *Le Morte Darthur.*

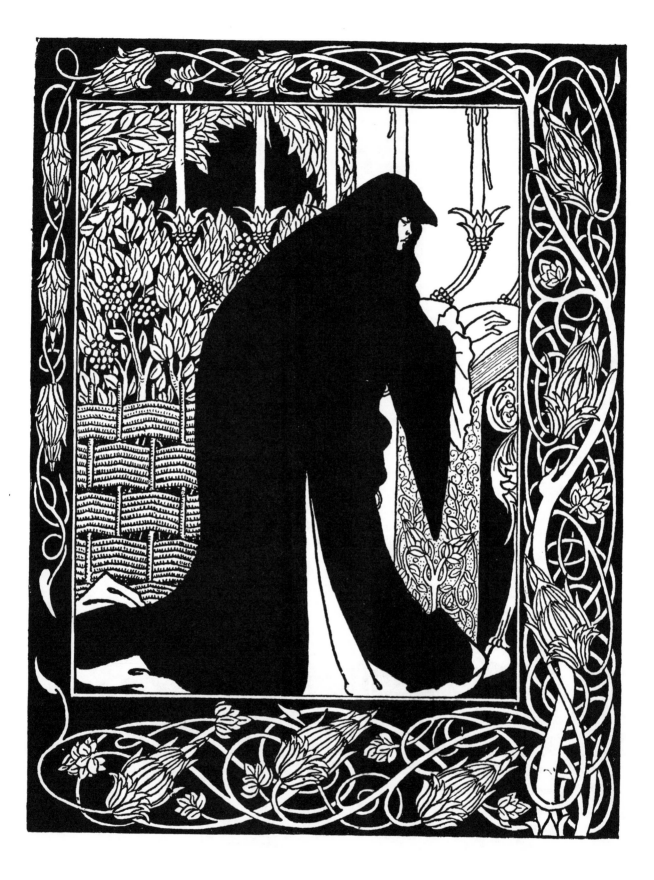

"How Queen Guenever Made Her a Nun," from Book
XXI, Chapter IX of *Le Morte Darthur.*

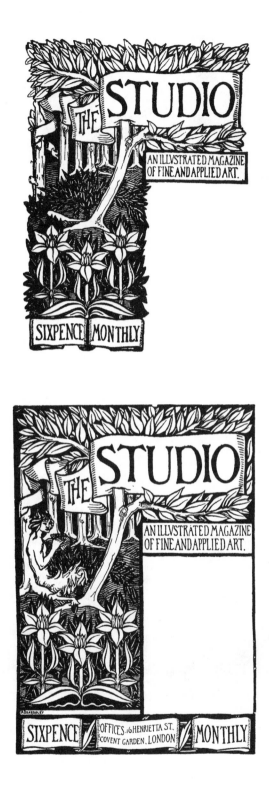

Two states of a cover design for *The Studio*, **No.** 1,
April 1893.

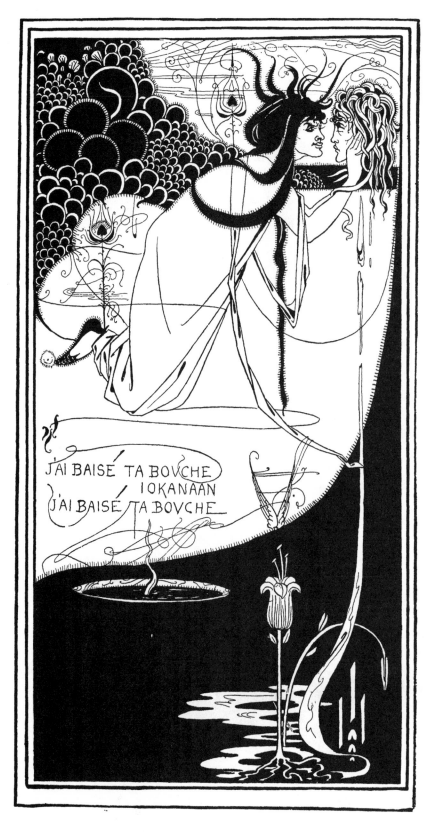

"J'ai Baisé Ta Bouche Iokanaan," from *The Studio*, No. 1.
This accompanied "A New Illustrator," an article by
illustrator Joseph Pennell introducing Beardsley to the
public. Another version of the same design appeared
later in the original 1894 edition of *Salome*, published
by John Lane. The inscription on the piece is a
quotation from the play.

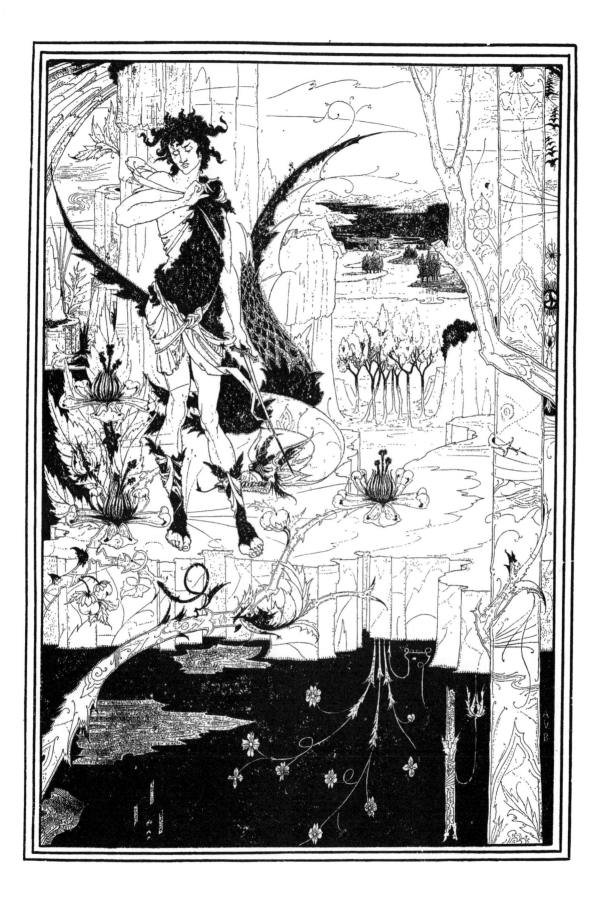

"Siegfried, Act II," from *The Studio*, No. 1.

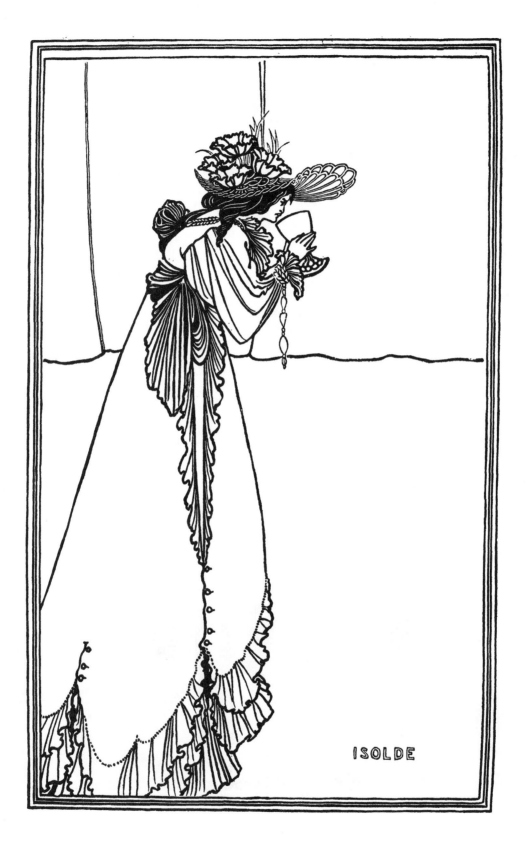

ISOLDE

"Isolde," from *The Studio*, No. 1.

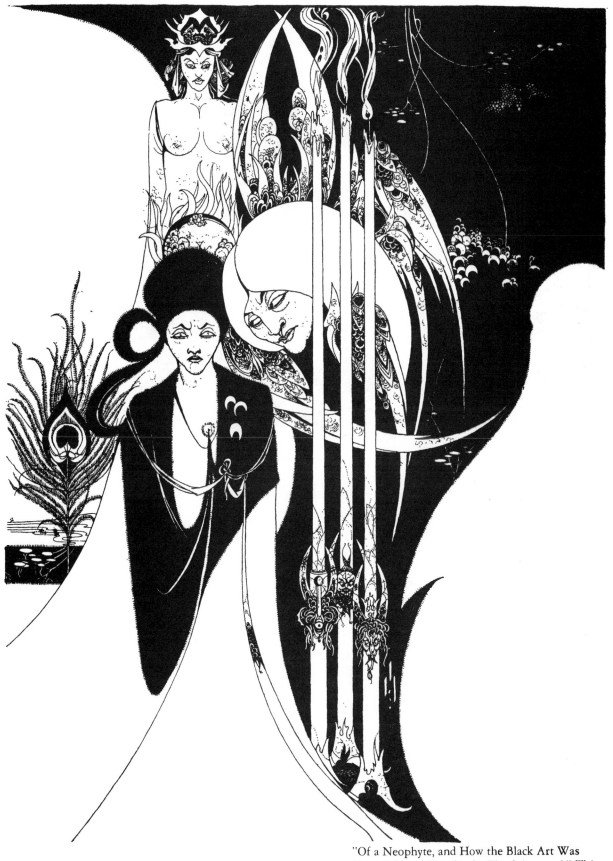

"Of a Neophyte, and How the Black Art Was Revealed unto Him by the Fiend Asomuel." This illustrated an article entitled "The Black Art," featured in *The Pall Mall Magazine*, June 1893.

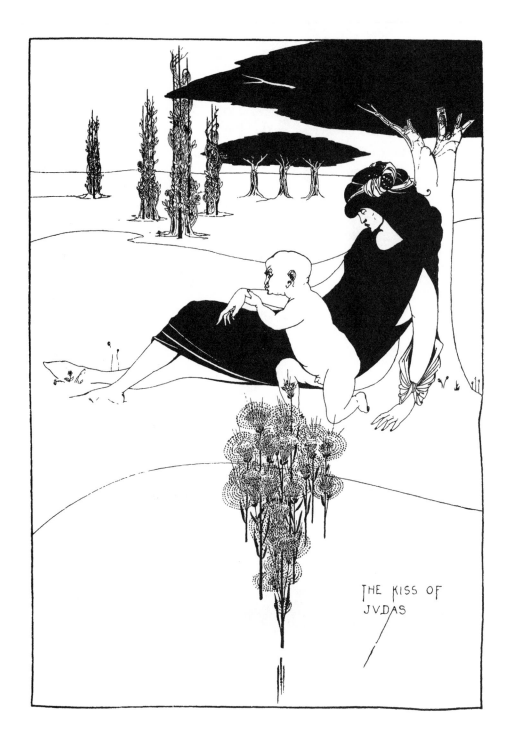

"**The Kiss of Judas**," illustrating "A Kiss of Judas," an
article featured in *The Pall Mall Magazine,* July 1893.

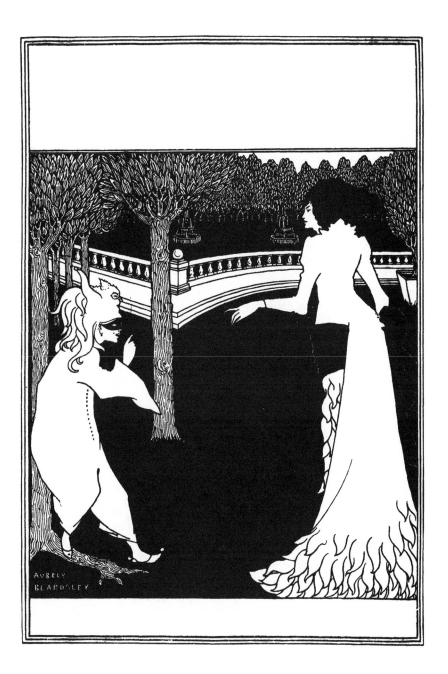

Cover design from *The Cambridge A.B.C.,* a magazine
published by undergraduates, June 1894.

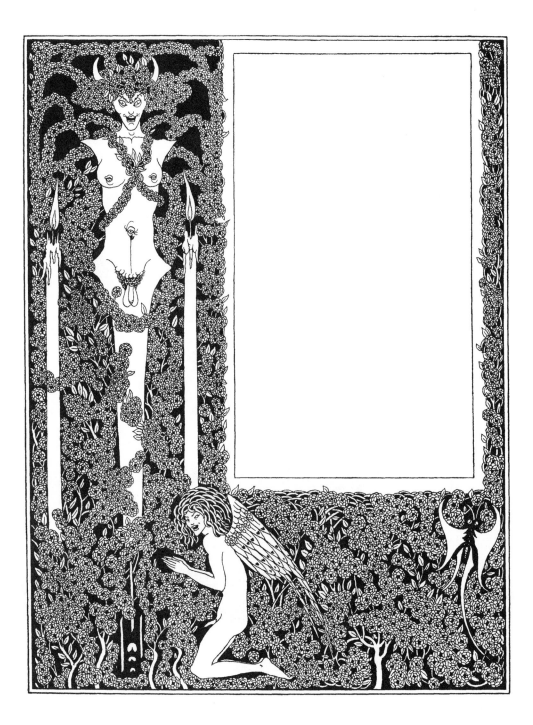

Title-page design from *Salome* by Oscar Wilde,
published by Elkin Mathews and John Lane, 1894.

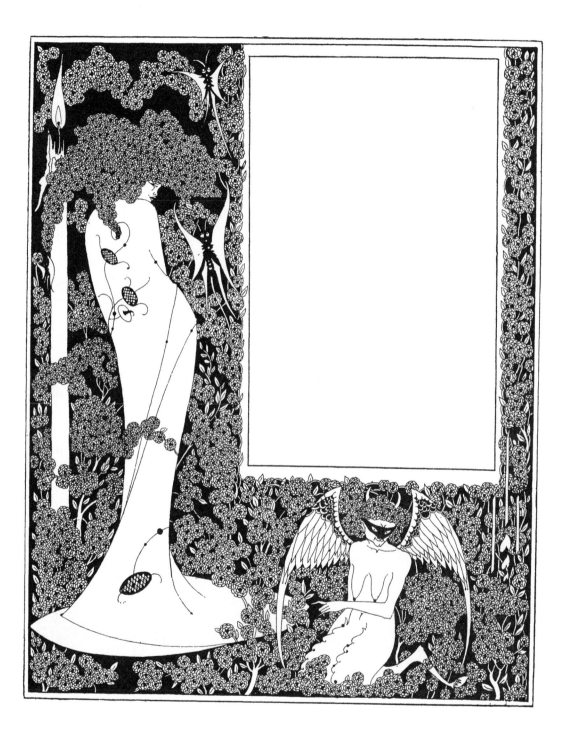

Contents-page design from *Salome*.

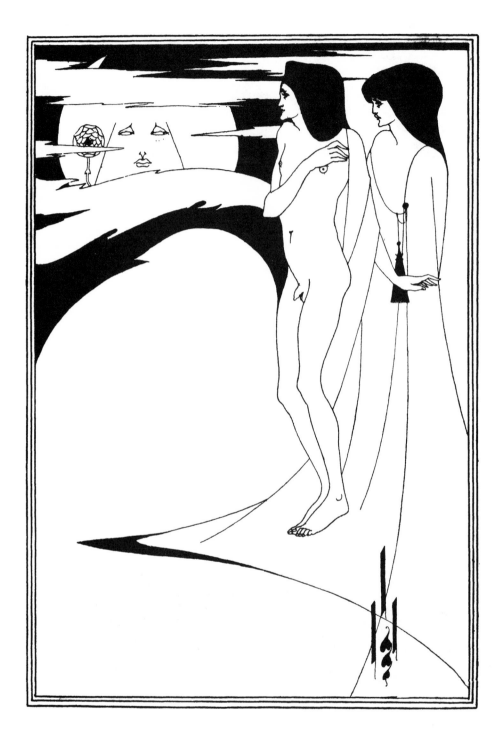

"The Woman in the Moon," frontispiece to *Salome*.

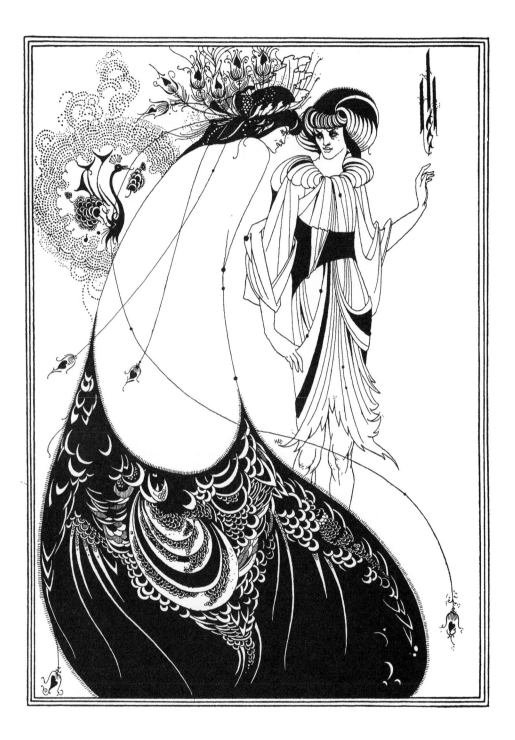

"The Peacock Skirt," from *Salome*.

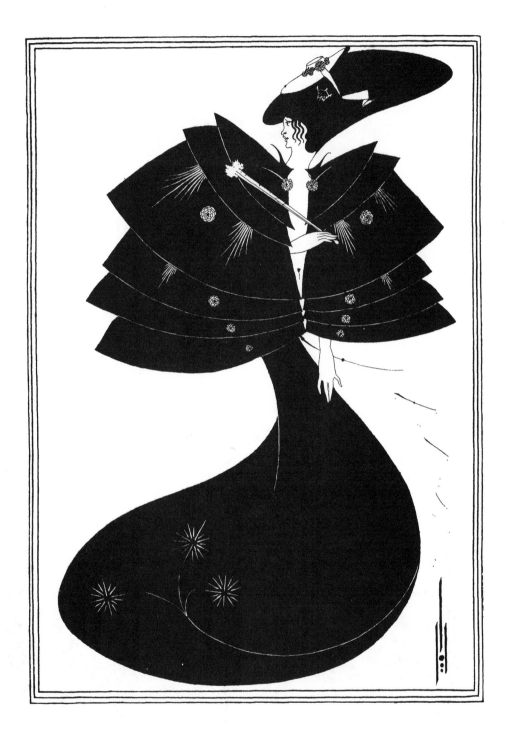

"The Black Cape," from *Salome*.

28

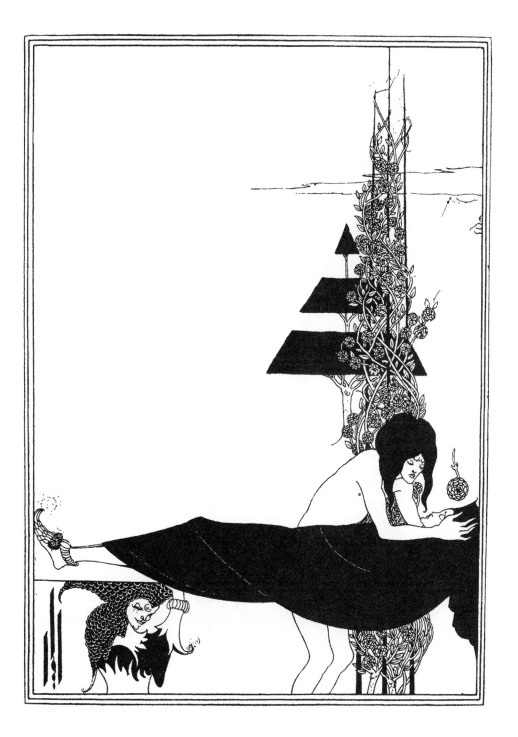

"The Platonic Lament," from *Salome.*

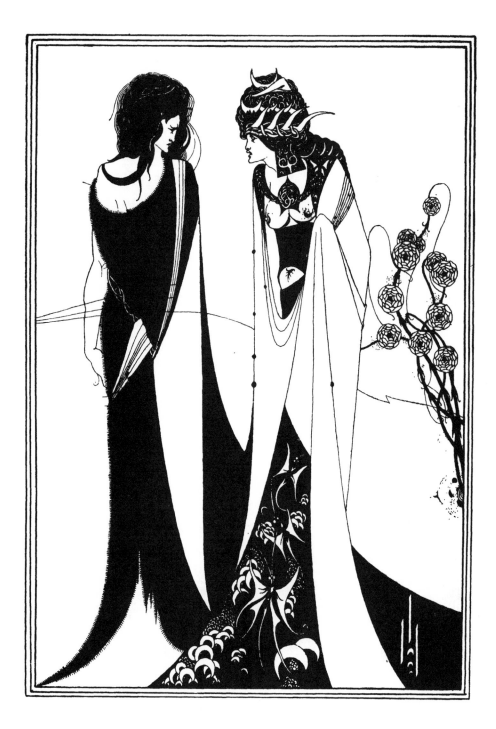

"John and Salome," intended for *Salome* but not
included in the original edition. At the time that the
play was first published, it was feared that the
depiction of John the Baptist would offend the public.

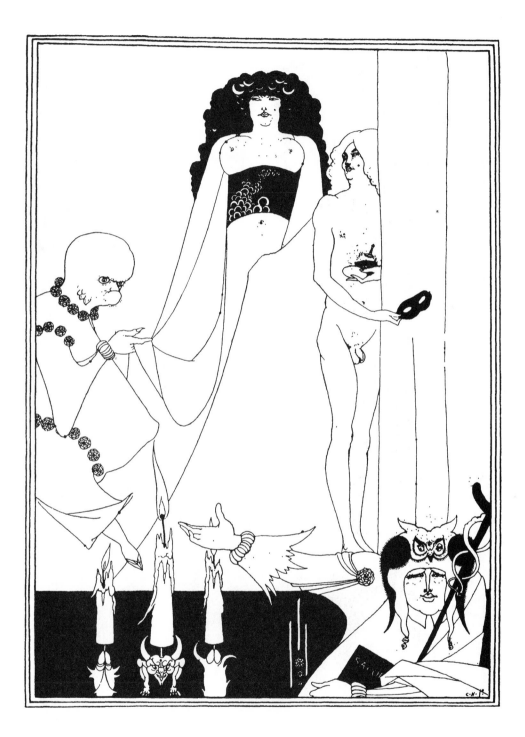

"Enter Herodias," from *Salome.* The figure in the lower right-hand corner, holding a copy of the play and gesturing toward the stage, is a caricature of Oscar Wilde.

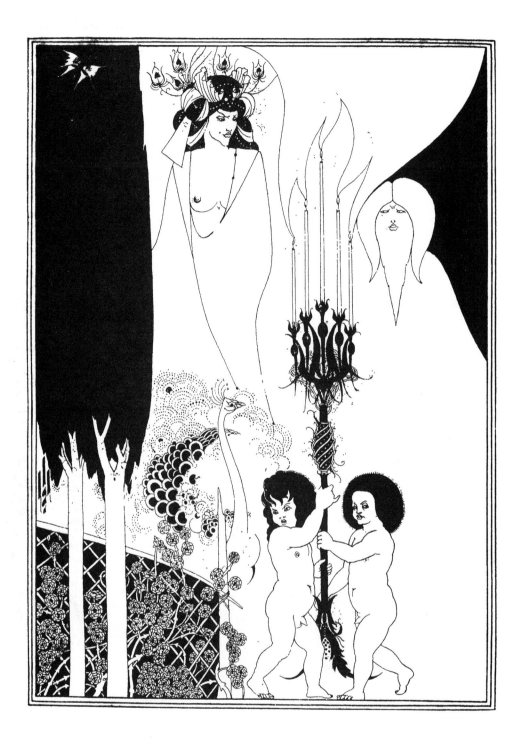

"The Eyes of Herod," from *Salome.*

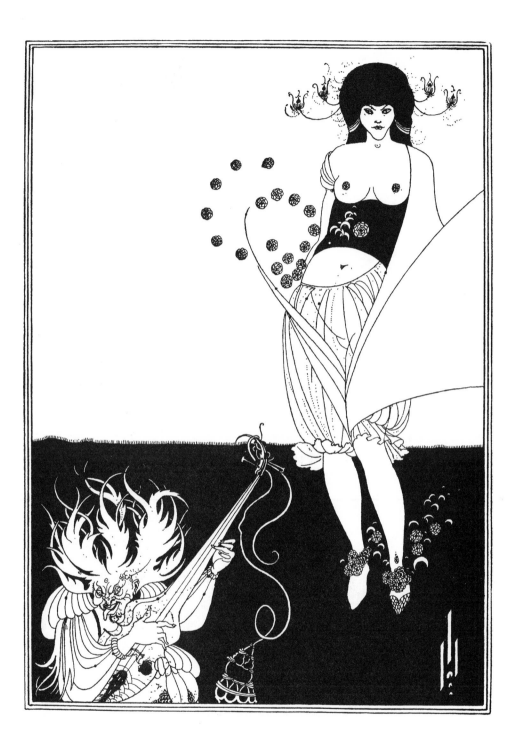

"The Stomach Dance," from *Salome*.

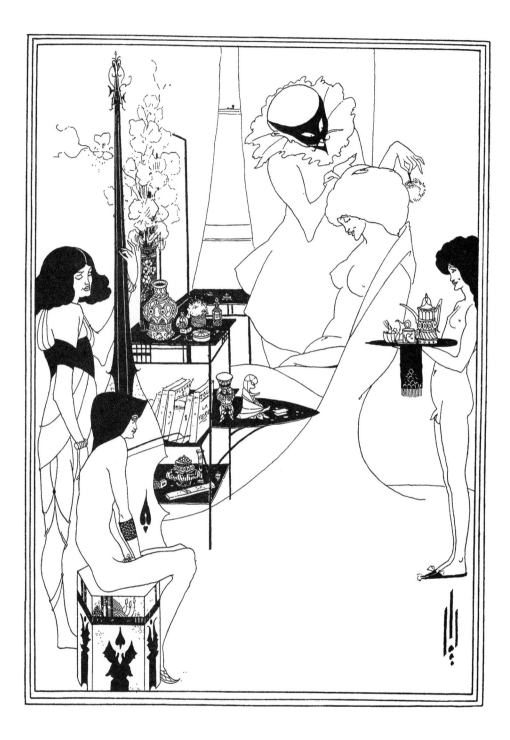

"The Toilette of Salome," first version, from *Salome*.
This illustration was suppressed from the original
edition of the book, and replaced by the following
drawing.

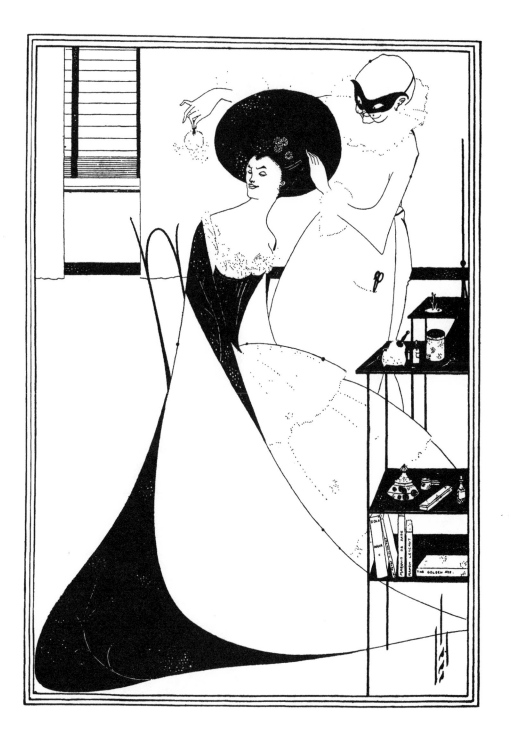

"The Toilette of Salome," second version, from
Salome. This is the version that appeared in the
original edition.

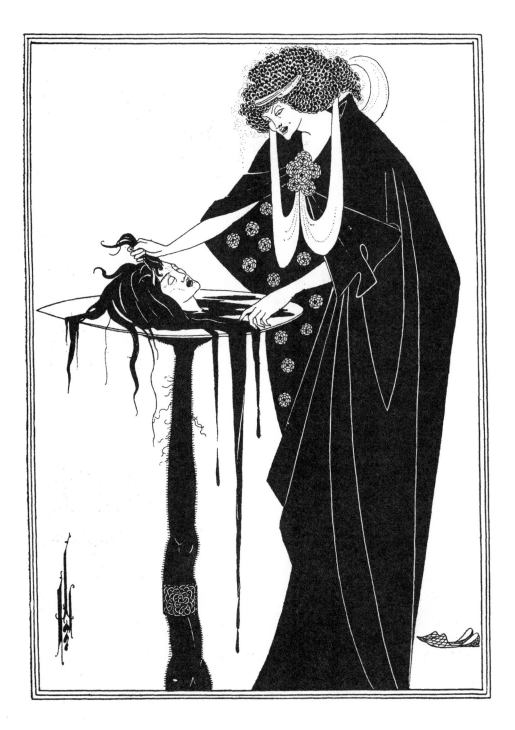

"The Dancer's Reward," from *Salome*.

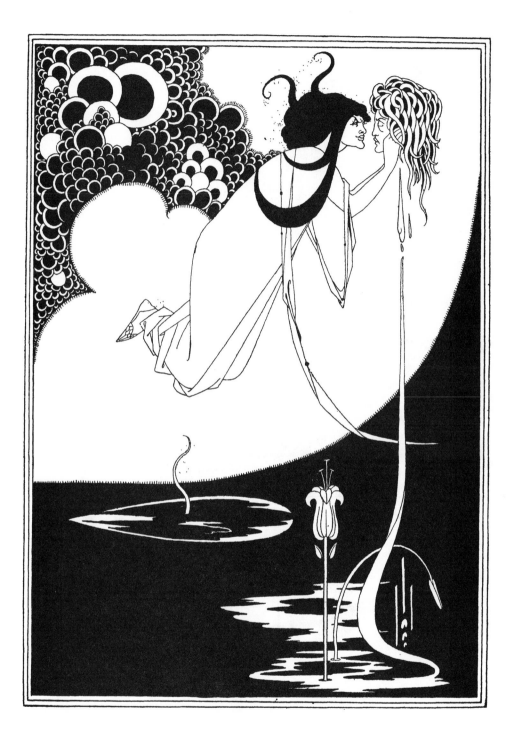

"The Climax," from *Salome.*

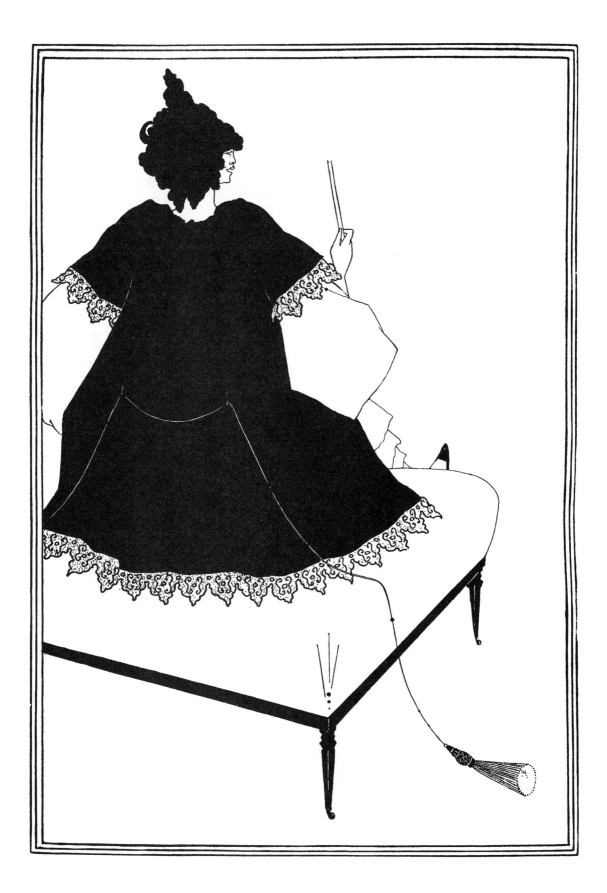

"Salome on Settle," intended for *Salome* but not
included in the original edition.

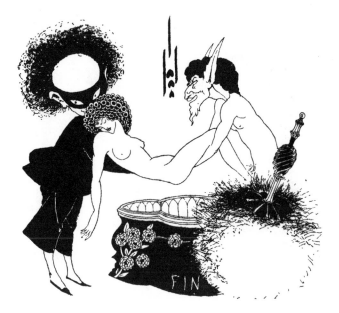

Tailpiece to *Salome*.

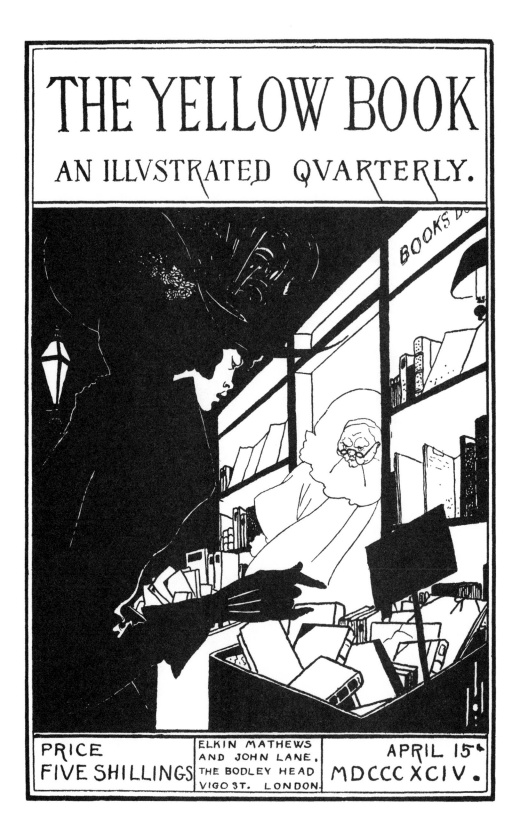

Cover design from the prospectus of *The Yellow Book*, April 1894.

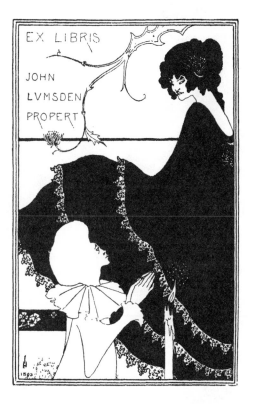

EX LIBRIS

JOHN
LVMSDEN
PROPERT

Book-plate design from *The Yellow Book,* Vol. I, April
1894.

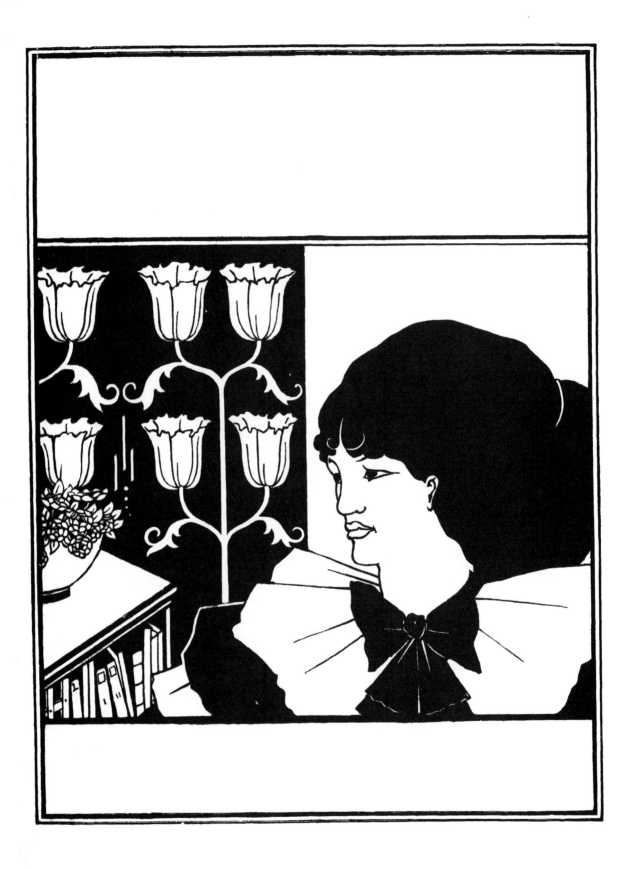

Cover design from *The Yellow Book,* Vol. II, July
1894.

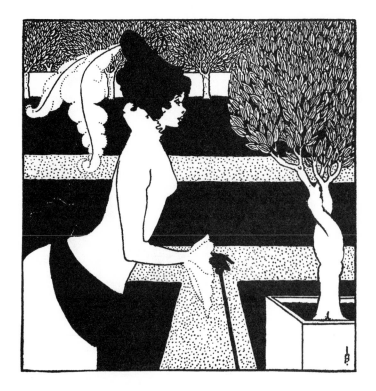

Title-page ornament from *The Yellow Book*, Vol. II.

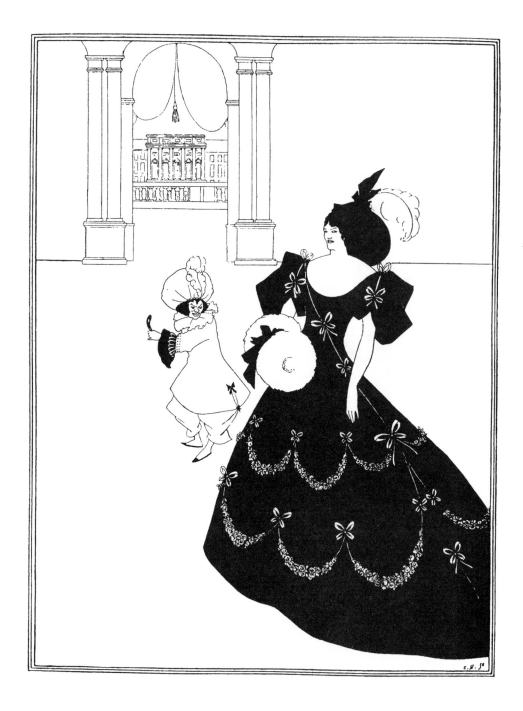

"Comedy-Ballet of Marionettes, I," from *The Yellow
Book,* Vol. II.

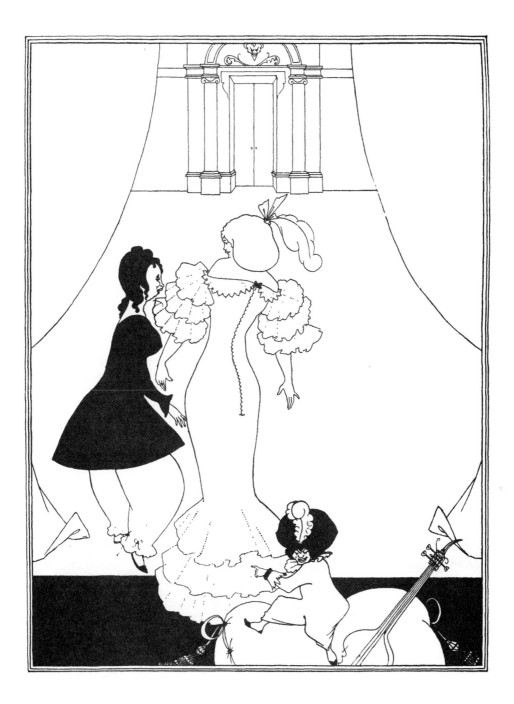

"Comedy-Ballet of Marionettes, II," from *The Yellow Book*, Vol. II.

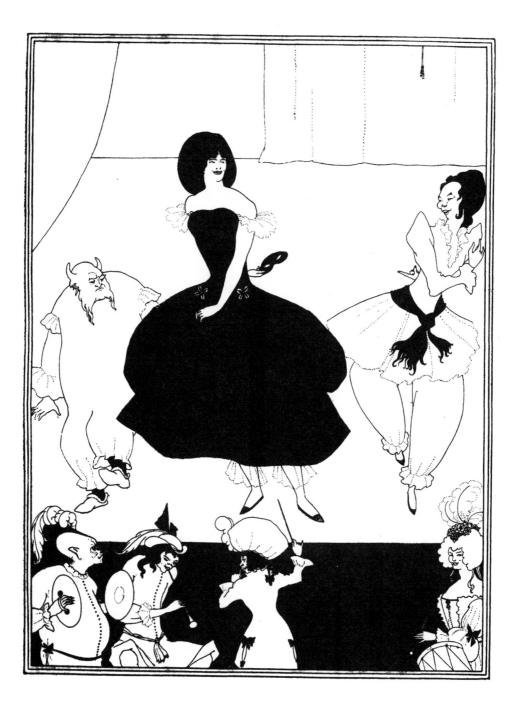

"Comedy-Ballet of Marionettes, III," from *The Yellow Book,* Vol. II.

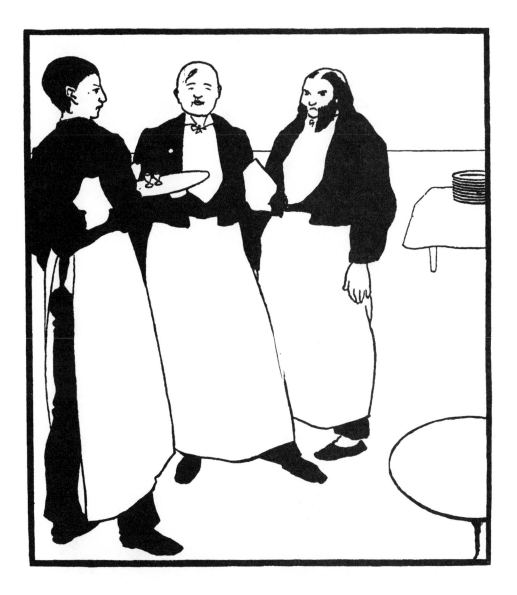

"Garçons de Café," from *The Yellow Book,* Vol. II.

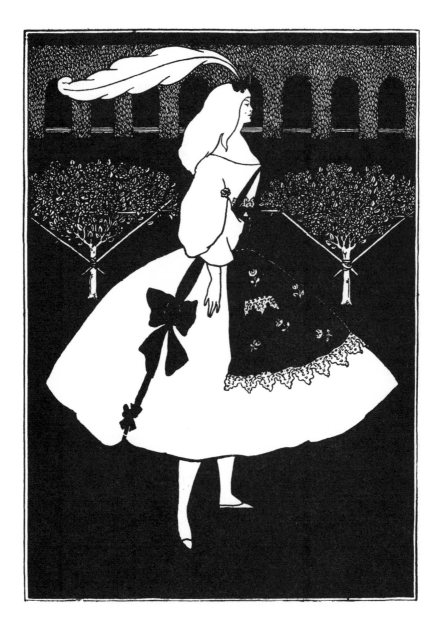

"The Slippers of Cinderella," from *The Yellow Book,*
Vol. II.

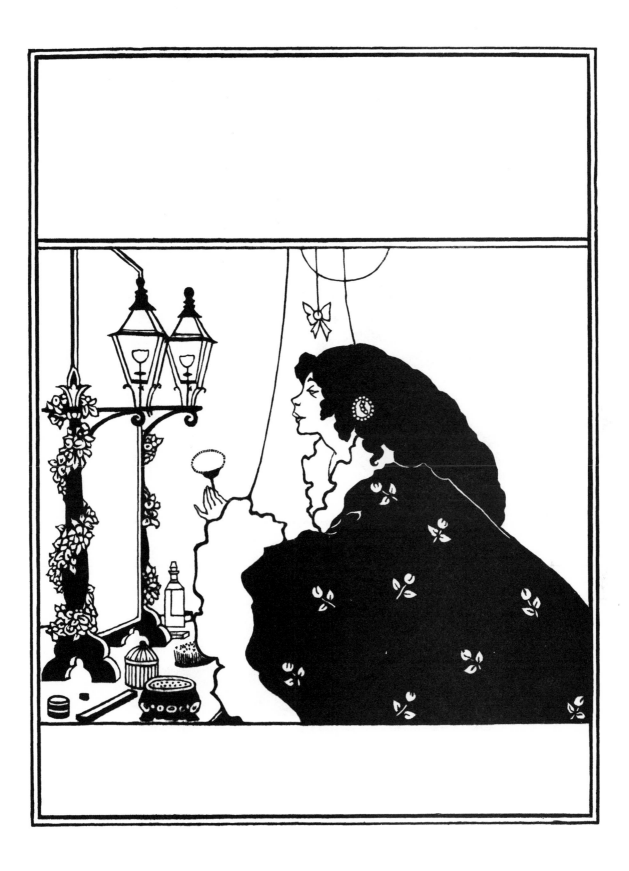

Cover design from *The Yellow Book*, Vol. III, October 1894.

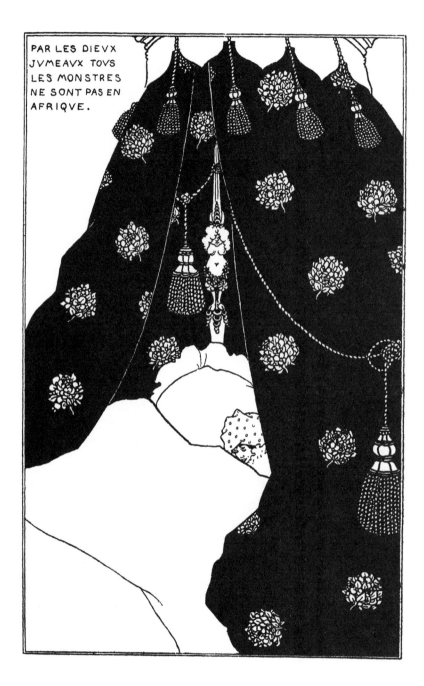

"Portrait of Himself," from *The Yellow Book,* Vol. III.
The French reads: "By the twin gods, not all monsters
are in Africa."

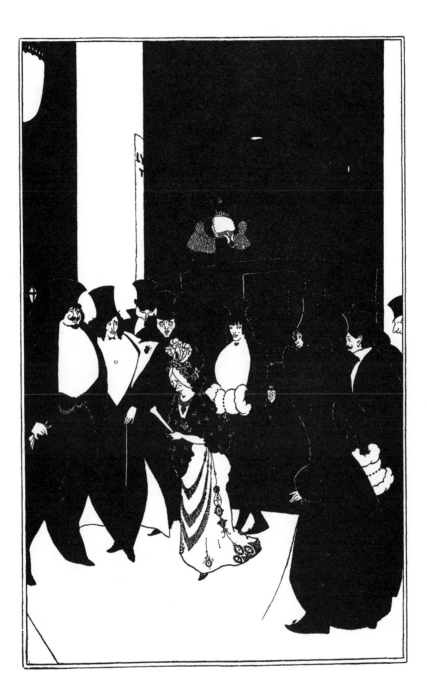

"Lady Gold's Escort," from *The Yellow Book,* Vol. III.

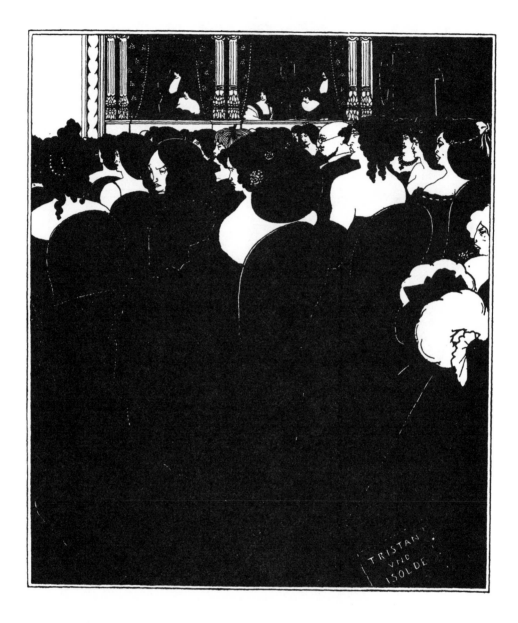

"The Wagnerites," from *The Yellow Book,* Vol. III.

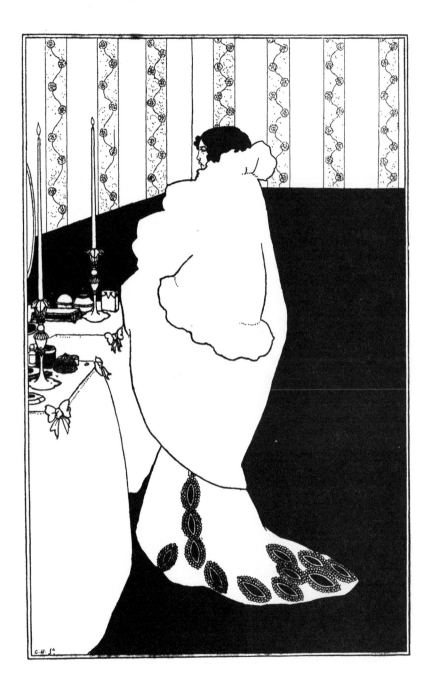

"La Dame Aux Camélias," inspired by the **Alexandre Dumas** *fils* work of the same name; from *The Yellow Book,* Vol. III.

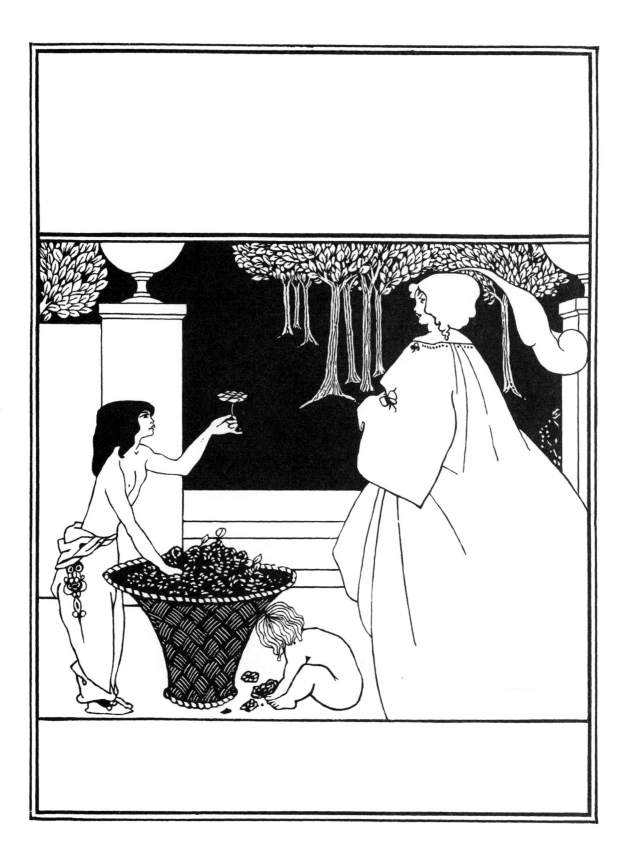

Cover design from *The Yellow Book,* Vol. IV, January
1895.

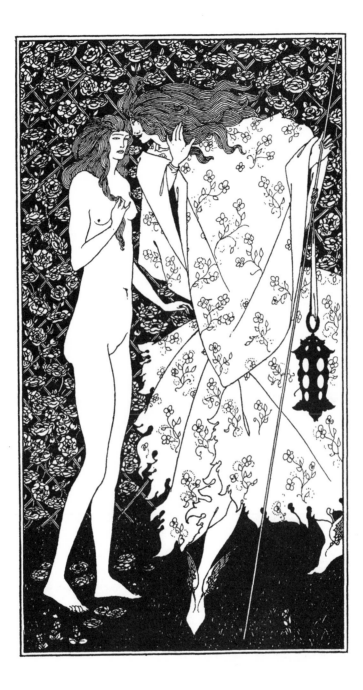

"The Mysterious Rose Garden," from *The Yellow Book,* Vol. IV.

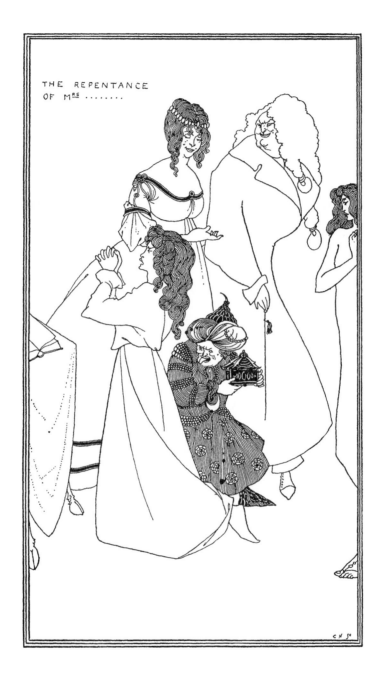

"The Repentance of Mrs. . . . ," from *The Yellow Book*, Vol. IV.

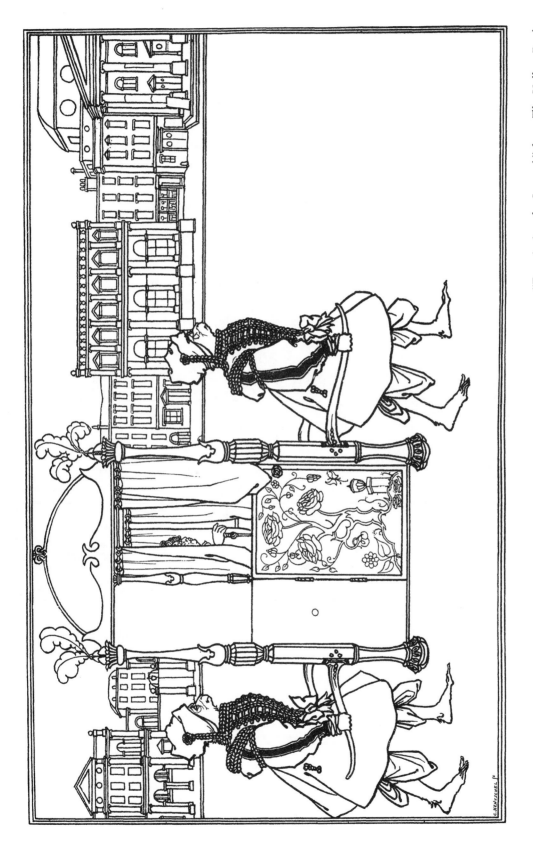

"Frontispiece for Juvenal," from *The Yellow Book,*
Vol. IV.

Cover design intended for *The Yellow Book*, but not
used.

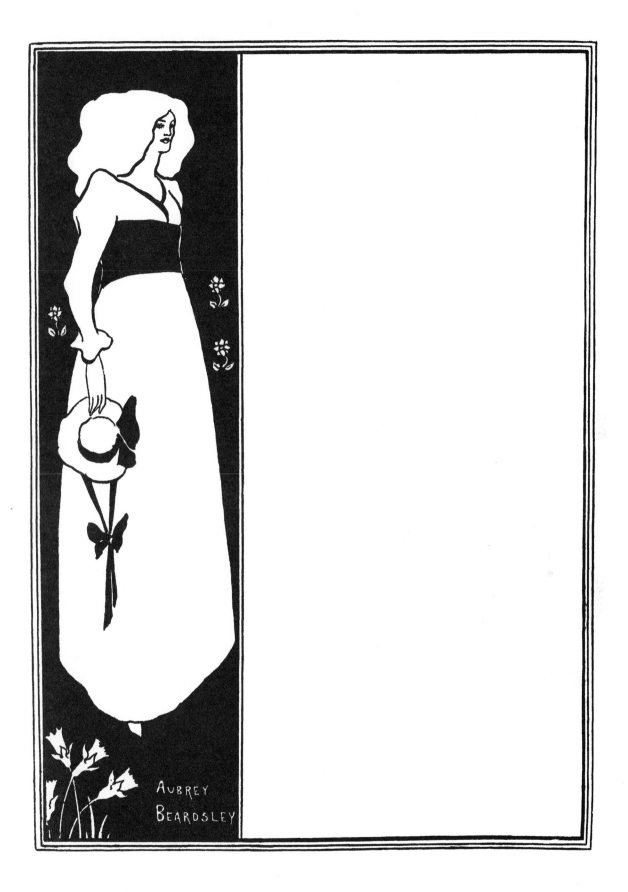

Poster for *The Yellow Book.*

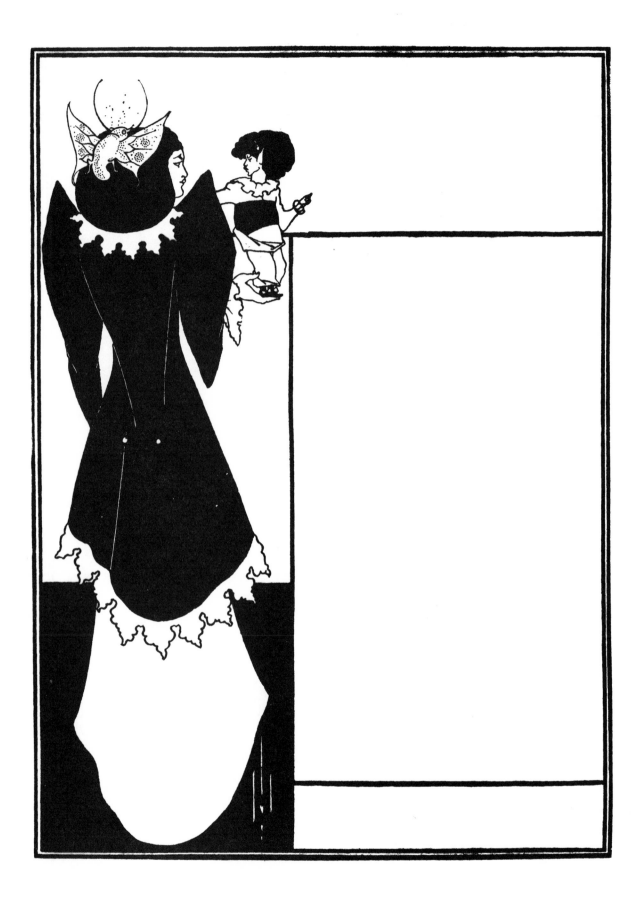

Poster design intended to advertise *The Yellow Book,*
but not used.

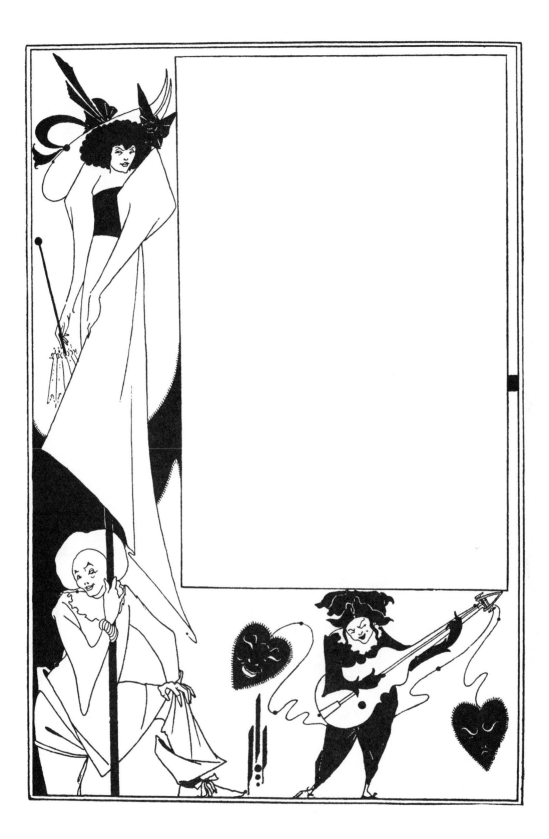

Cover design from *Keynotes* by George Egerton, published in the Keynotes series by John Lane, 1894. Beardsley designed all the covers for the novels in this series, giving them all similar formats.

Cover design from *A Child of the Age* by Francis
Adams, published in the Keynotes series, 1894.

Cover design from *The Great God Pan* by Arthur
Machen, published in the Keynotes series, 1894.

Cover design from *Discords* by George Egerton, published in the Keynotes series, 1894.

Cover design from *Prince Zaleski* by M. P. Shiel, published in the Keynotes series, 1895.

Cover design from *The Woman Who Did* by Grant
Allen, published in the Keynotes series, 1895.

Cover design from *Women's Tragedies* by H. D.
Lowry, published in the Keynotes series, 1895.

Cover design from *Grey Roses* by Henry Harland, published in the Keynotes series, 1895.

Cover design from *At the First Corner* by H. B. Marriott Watson, published in the Keynotes series, 1895.

Cover design from *Monochromes* by Ella D'Arcy, published in the Keynotes series, 1895.

Cover design from *At the Relton Arms* by Evelyn Sharp, published in the Keynotes series, 1895.

Cover design from *The Girl from the Farm* by
Gertrude Dix, published in the Keynotes series, 1895.

Cover design from *The Mirror of Music* by Stanley V.
Makower, published in the Keynotes series, 1895.

Cover design from *Yellow and White* by W. Carlton
Dawe, published in the Keynotes series, 1895.

Cover design from *The Mountain Lovers* by Fiona
MacLeod, published in the Keynotes series, 1895.

Cover design from *The Woman Who Didn't* by
Victoria Crosse, published in the Keynotes series,
1895.

Cover design from *The Three Impostors* by Arthur
Machen, published in the Keynotes series, 1895.

Cover design from *The British Barbarians* by Grant Allen, published in the Keynotes series, 1895.

Cover design from *The Barbarous Britishers* by H. D. Traill, 1895. Given the format of this cover design and the time of publication, the book was likely to have been connected with the Keynotes series.

Cover design from *Young Ofeg's Ditties* by Ola Hansson, 1895. This book was also likely to have been connected with the Keynotes series, given the format of its cover design and its date of publication.

Cover design from *Nobody's Fault* by Netta Syrett, published in the Keynotes series, 1896.

Cover design from *Platonic Affections* by John Smith,
published in the Keynotes series, 1896.

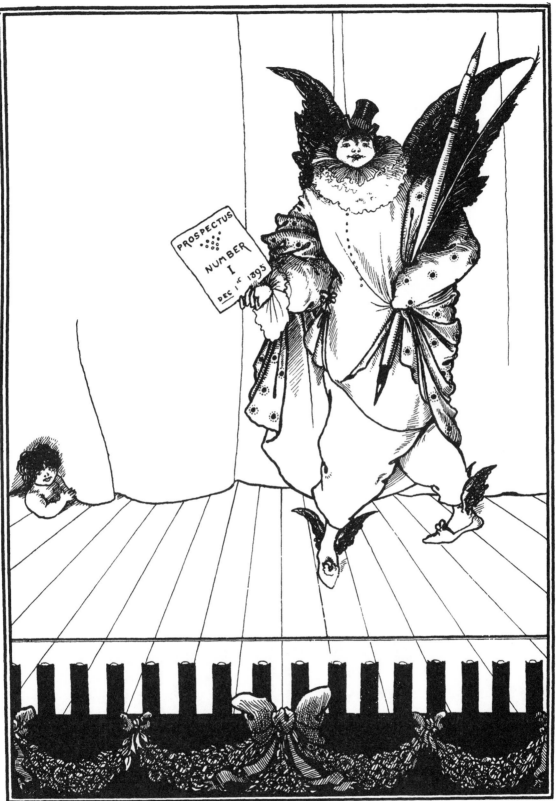

AVBREY BEARDSLEY

Cover design for the prospectus of *The Savoy*,
December 1895.

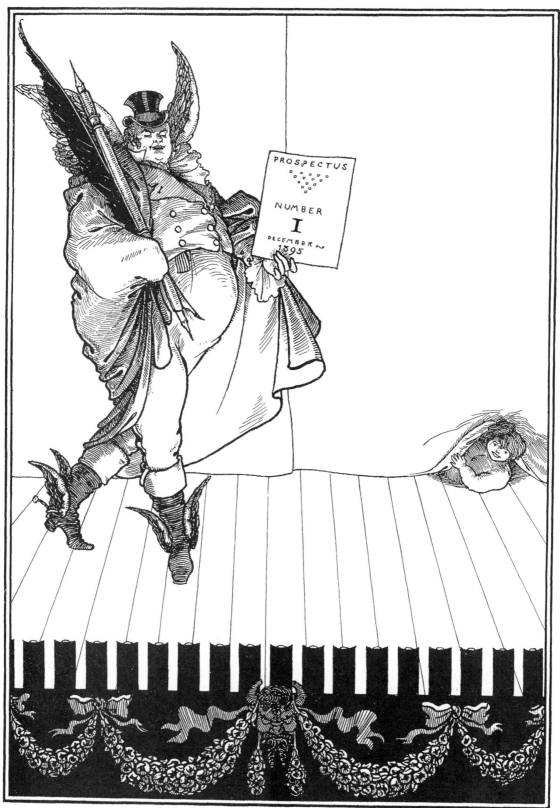

Another cover design for the prospectus of *The Savoy*.

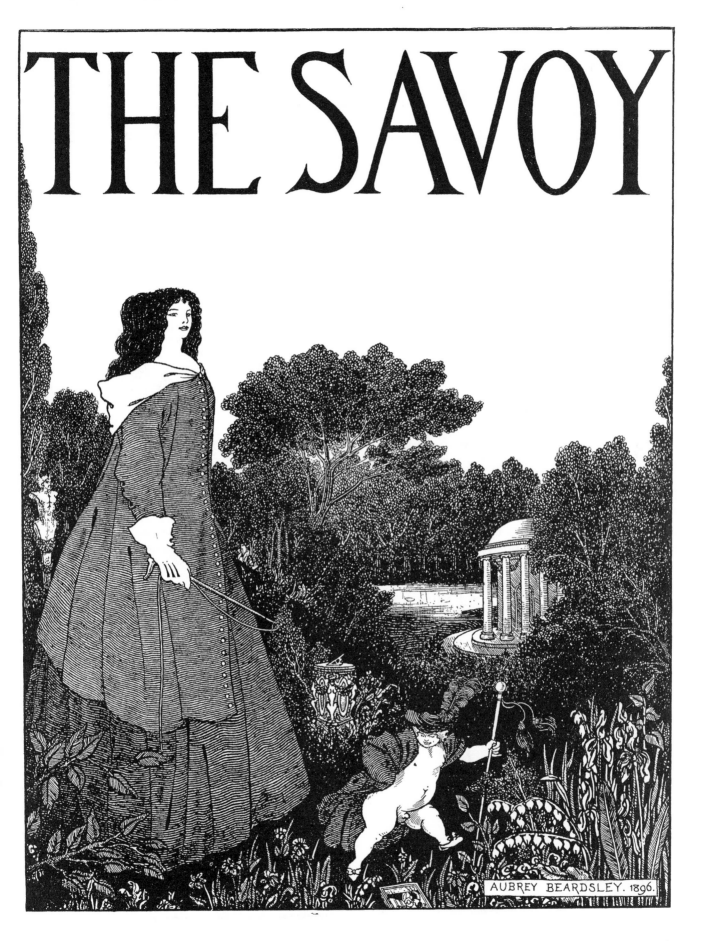

Cover design from *The Savoy*, No. 1, January 1896.

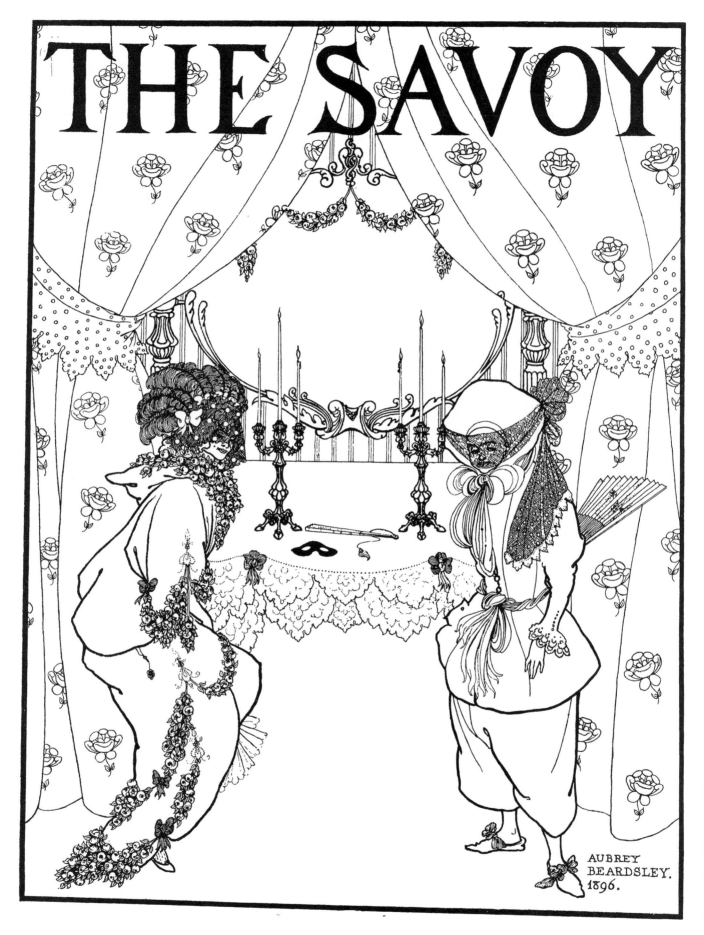

Title-page design from *The Savoy*, Nos. 1 and 2.

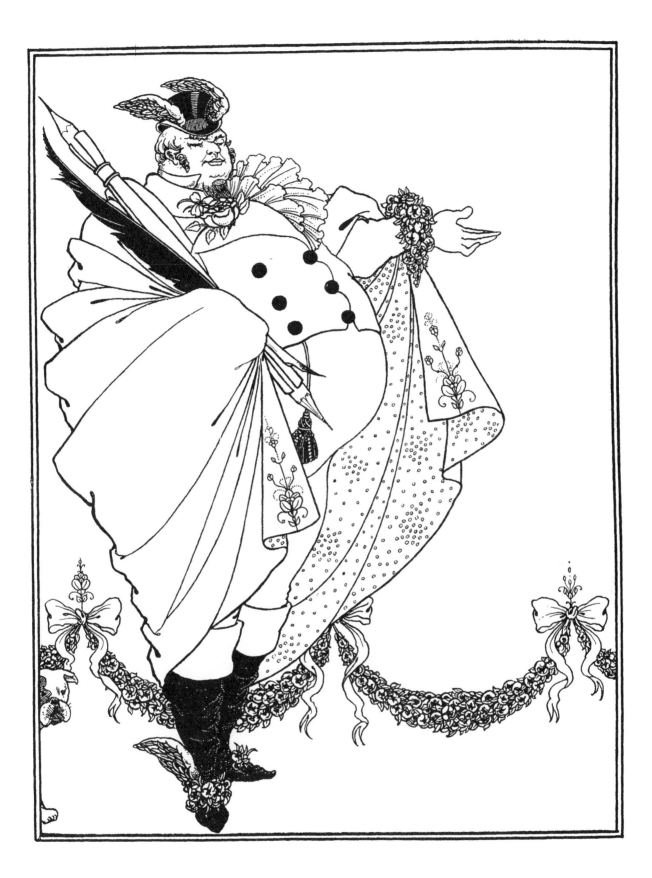

Contents-page design from *The Savoy*, No. 1.

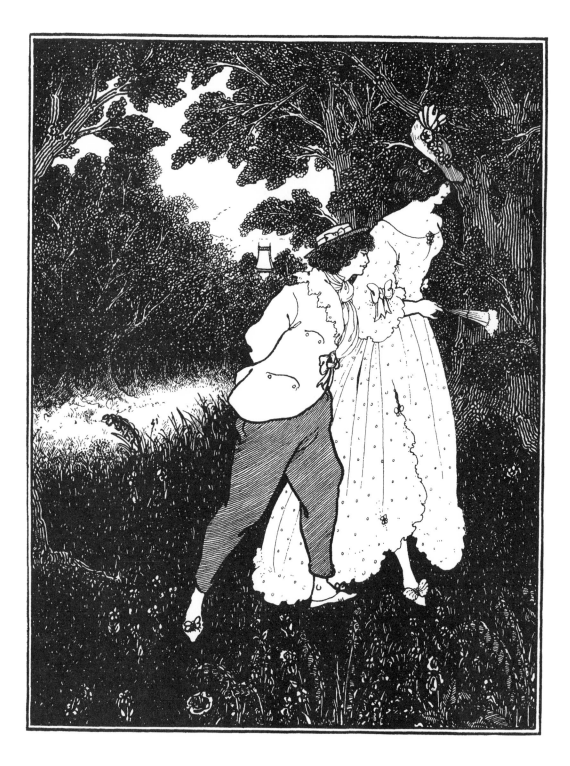

Illustration for "The Three Musicians," a poem by
Aubrey Beardsley appearing in *The Savoy,* No. 1.

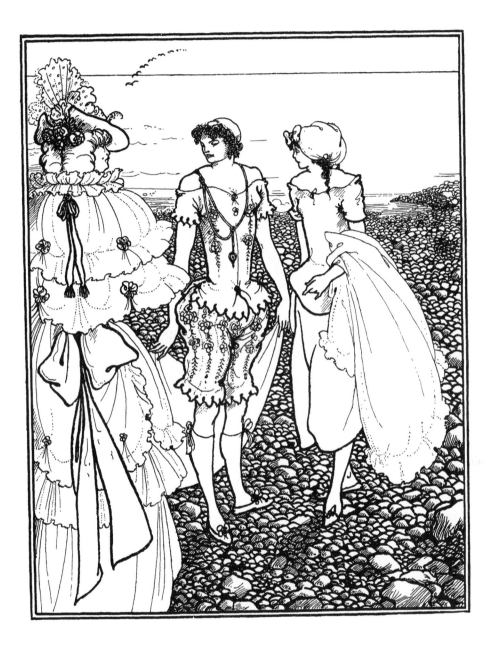

"On Dieppe Beach" (or "The Bathers"), illustrating
"Dieppe: 1895," an article by Arthur Symons featured
in *The Savoy,* No. 1.

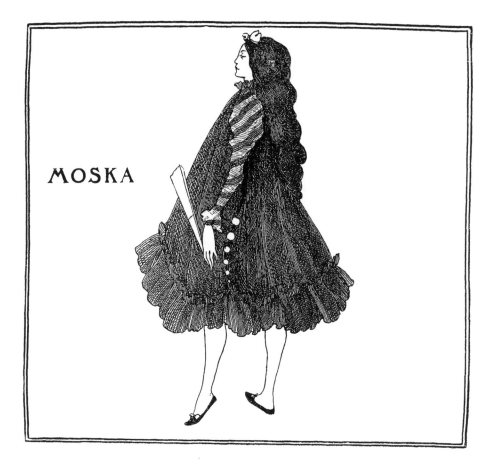

MOSKA

"The Moska," illustrating the article "Dieppe: 1895"
in *The Savoy*, No. 1. The Moska is a dance at a
children's ball described in the article.

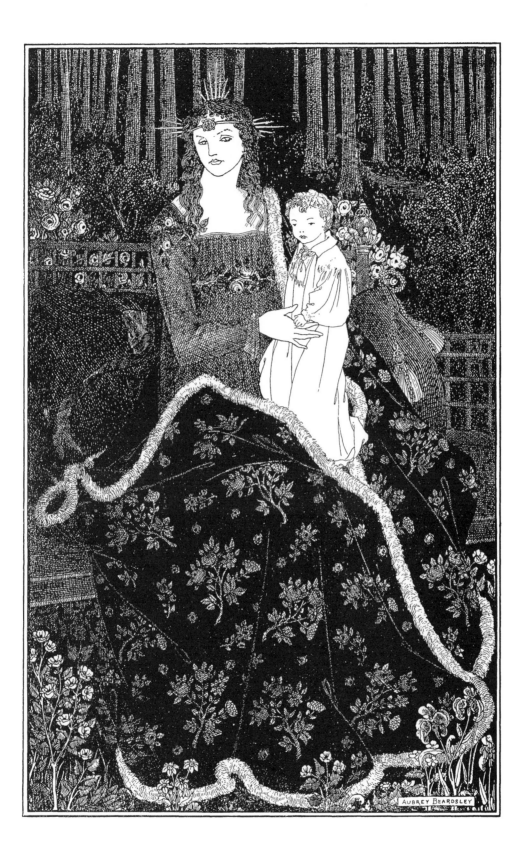

"A Christmas Card," a loose insert in *The Savoy*, No. 1.

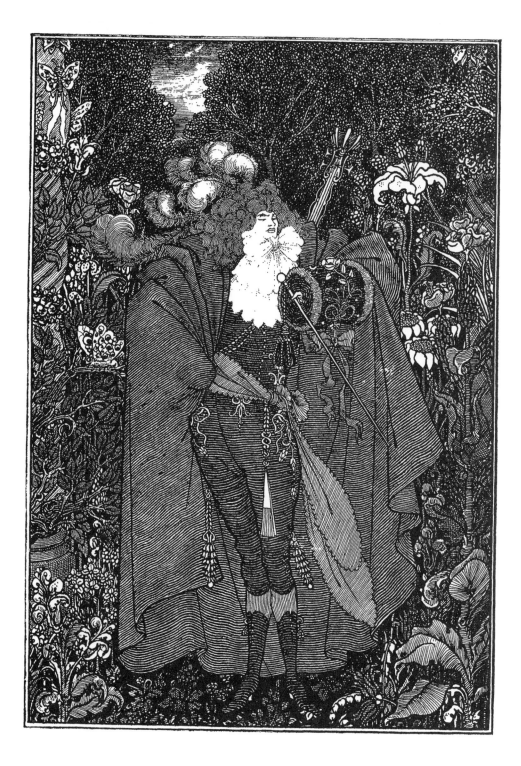

"The Abbé," illustrating *Under the Hill,* an unfinished
novel by Beardsley, in *The Savoy,* No. 1. The novel
appeared in *The Savoy* in two parts, the first in No. 1
and the second in No. 2.

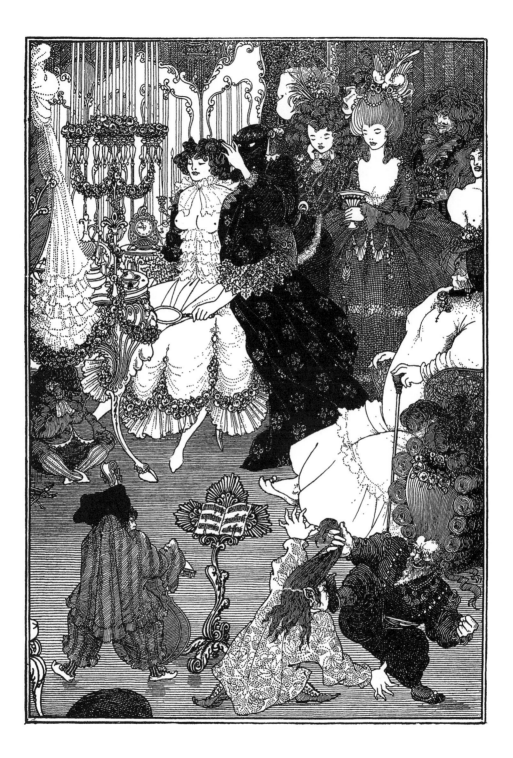

"The Toilet of Helen," illustrating *Under the Hill* in
The Savoy, No. 1.

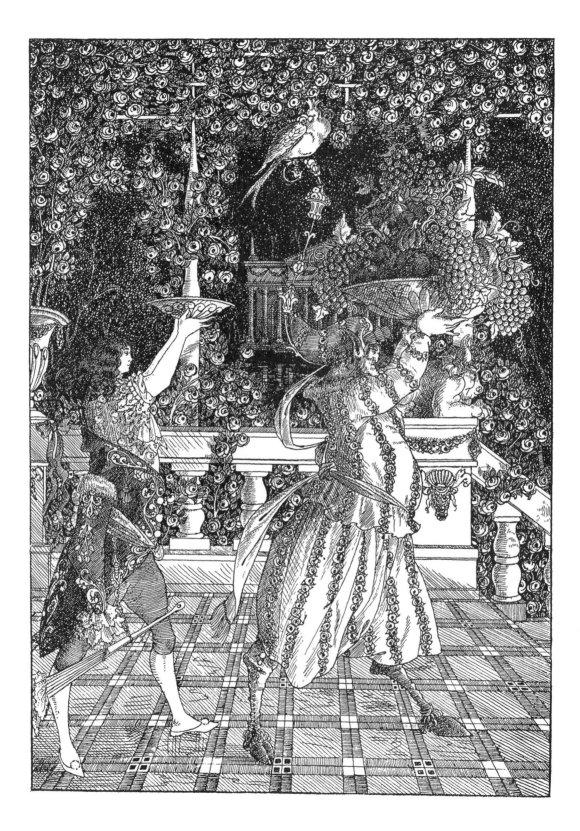

"The Fruit-Bearers," illustrating *Under the Hill* in
The Savoy, No. 1.

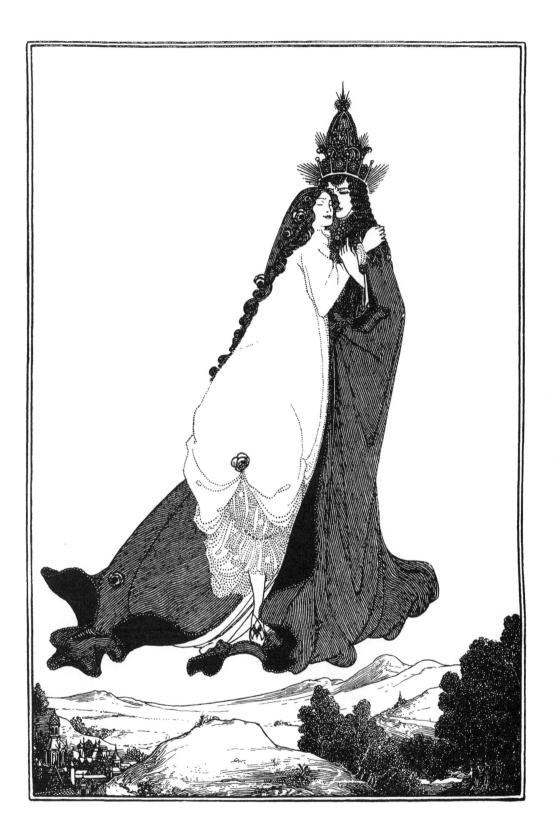

"The Ascension of St. Rose of Lima," illustrating
Under the Hill in *The Savoy*, No. 2, April 1896.

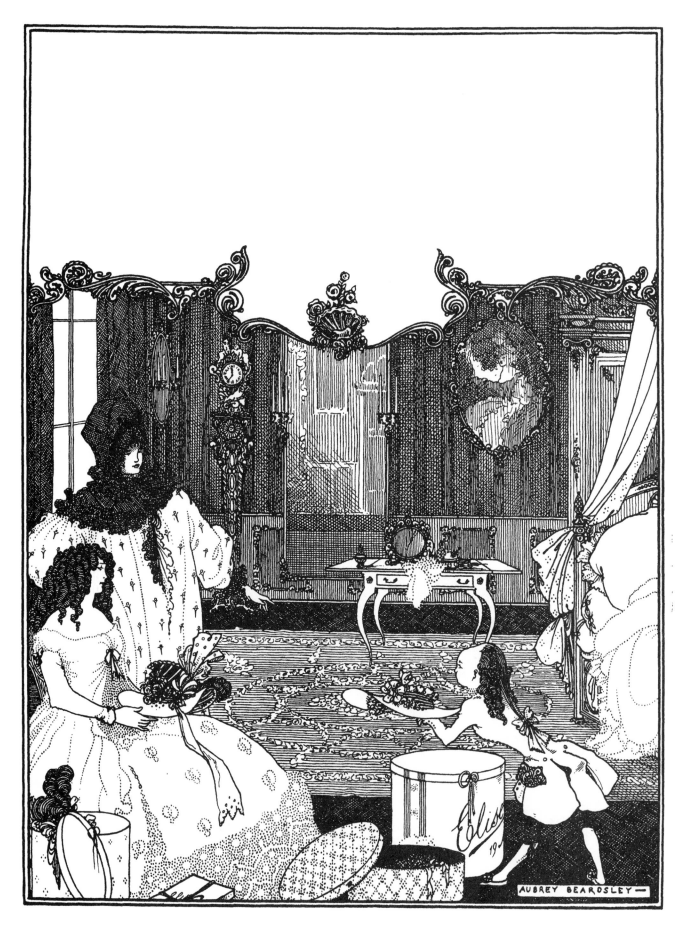

Cover design from *The Savoy*, No. 2.

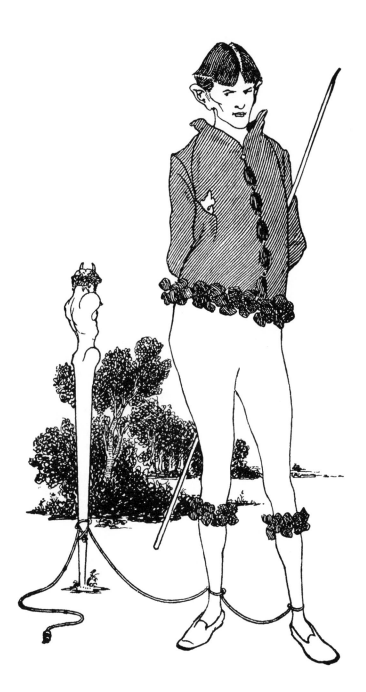

"A Footnote," a self-portrait, from *The Savoy*, No. 2.

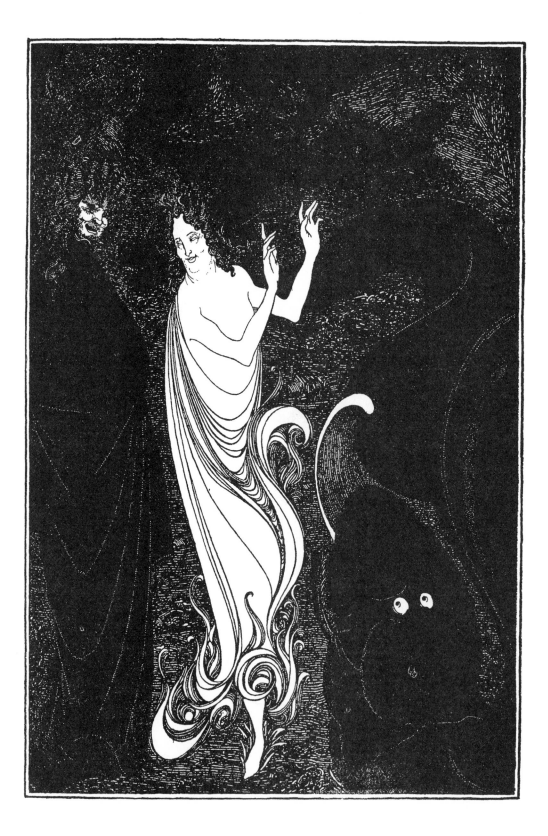

"The Third Tableau of Das Rheingold," from *The Savoy,* No. 2.

Cover design from *The Savoy*, No. 3, July 1896.

THE SAVOY

"Puck," the title-page design from *The Savoy*, Nos. 3–8.

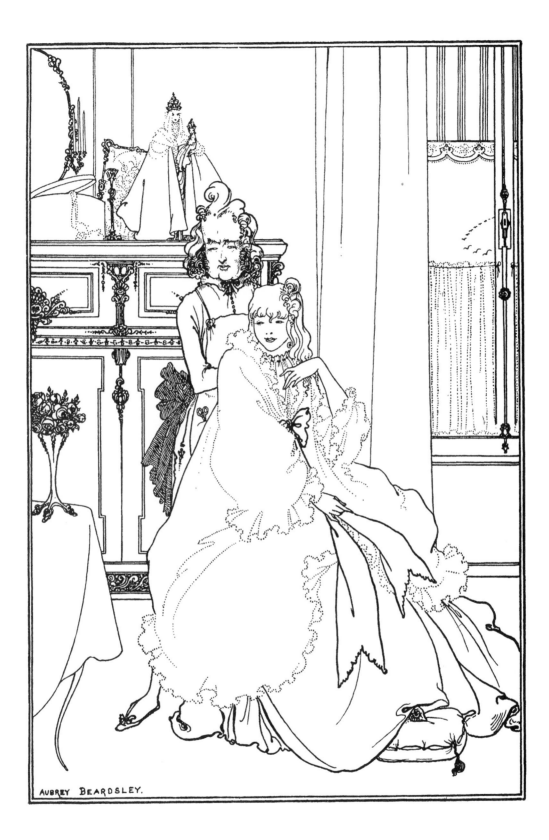

AUBREY BEARDSLEY.

"The Coiffing," illustrating "The Ballad of a Barber," a
poem by Beardsley featured in *The Savoy*, No. 3.

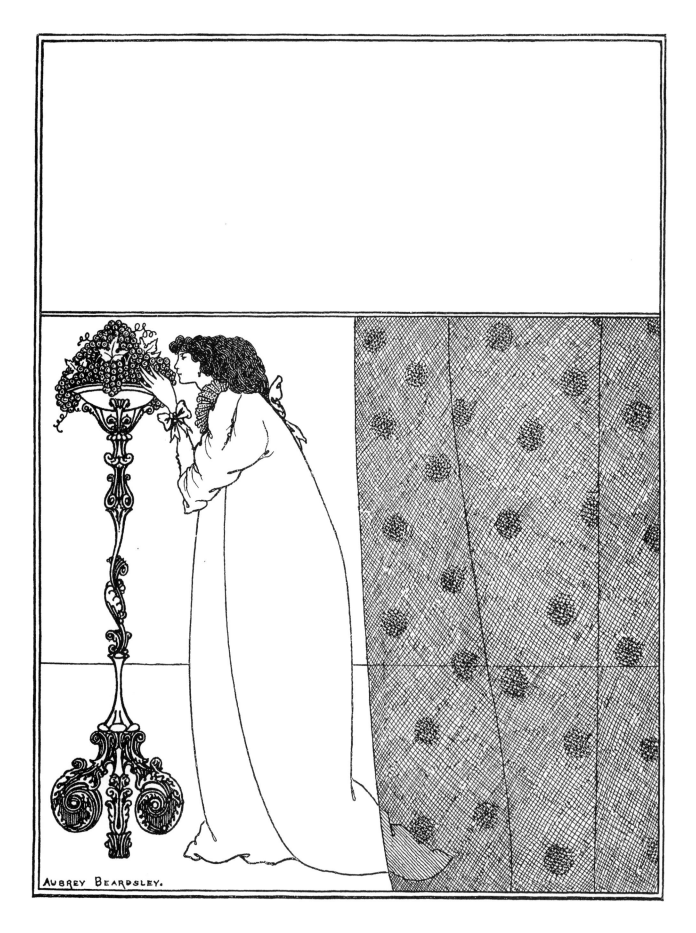

Cover design from *The Savoy*, No. 4, August 1896.

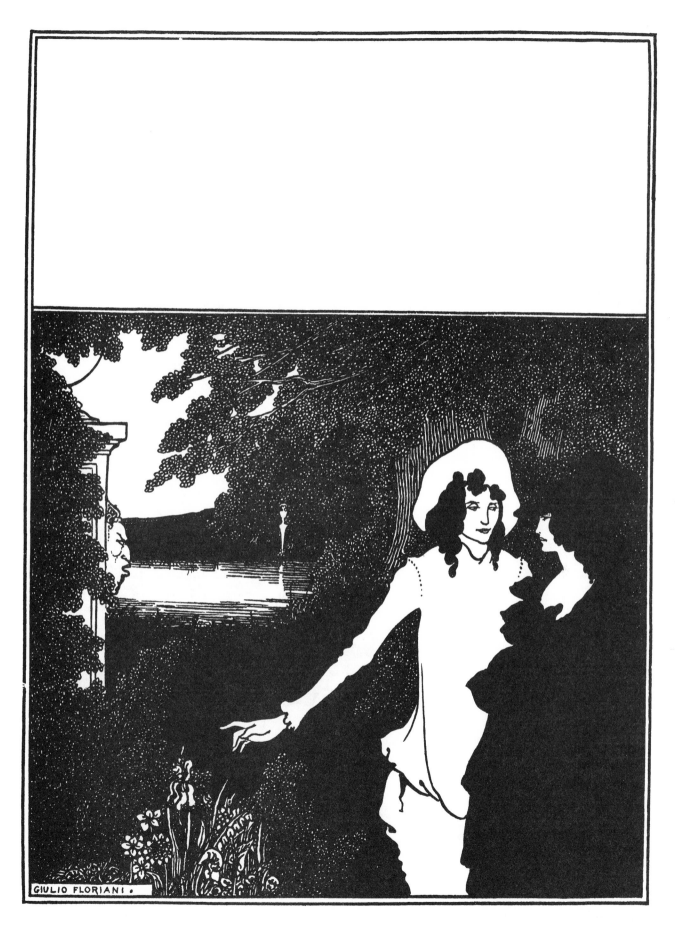

Cover design from *The Savoy,* No. 5, September 1896.

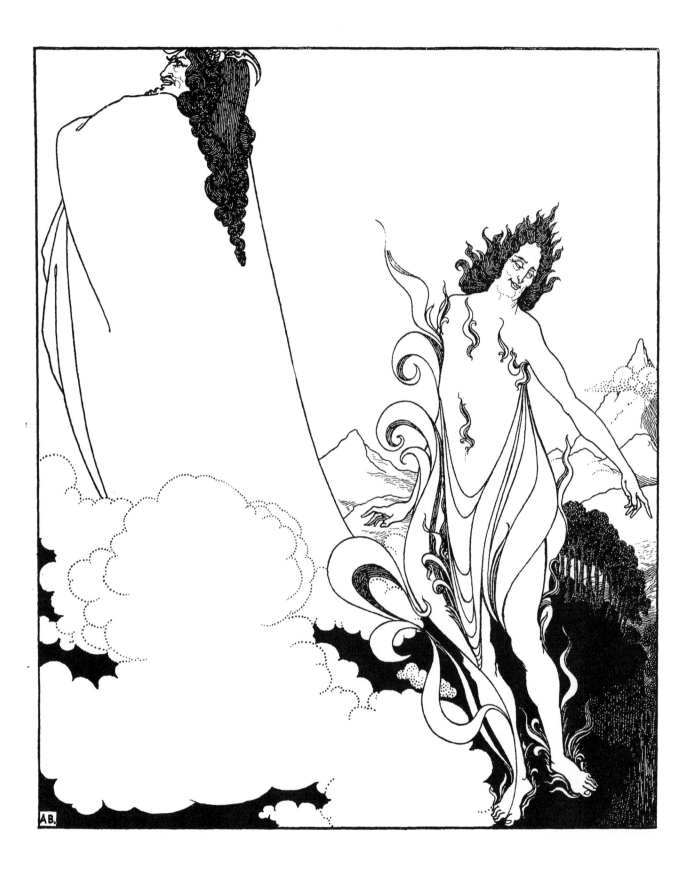

"The Fourth Tableau of Das Rheingold," the cover
design from *The Savoy,* No. 6, October 1896.

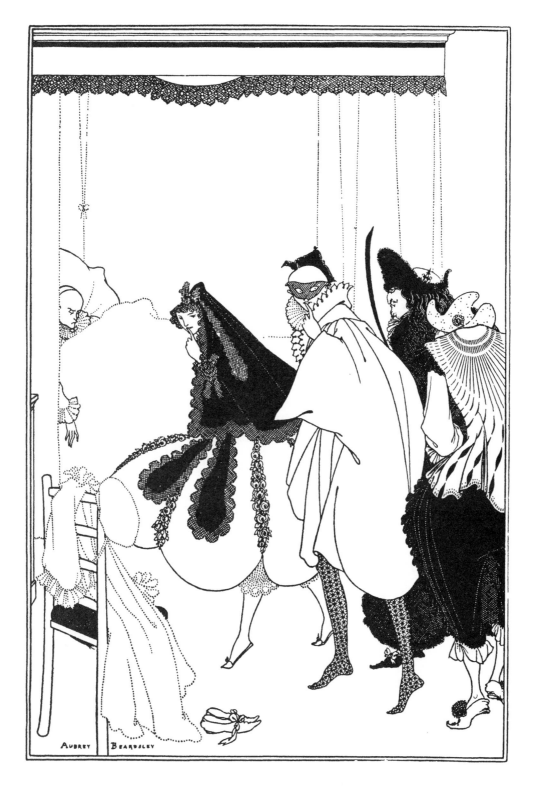

"The Death of Pierrot," from *The Savoy,* No. 6. In
The Savoy, this drawing was accompanied by the
following legend: "As the dawn broke, Pierrot fell into
his last sleep. Then upon tiptoe, silently up the stair,
noiselessly into the room, came the comedians,
Arlecchino, Pantaleone, Il Dottore, and Columbina,
who with much love carried away upon their shoulders
the white-frocked clown of Bergamo; whither, we
know not."

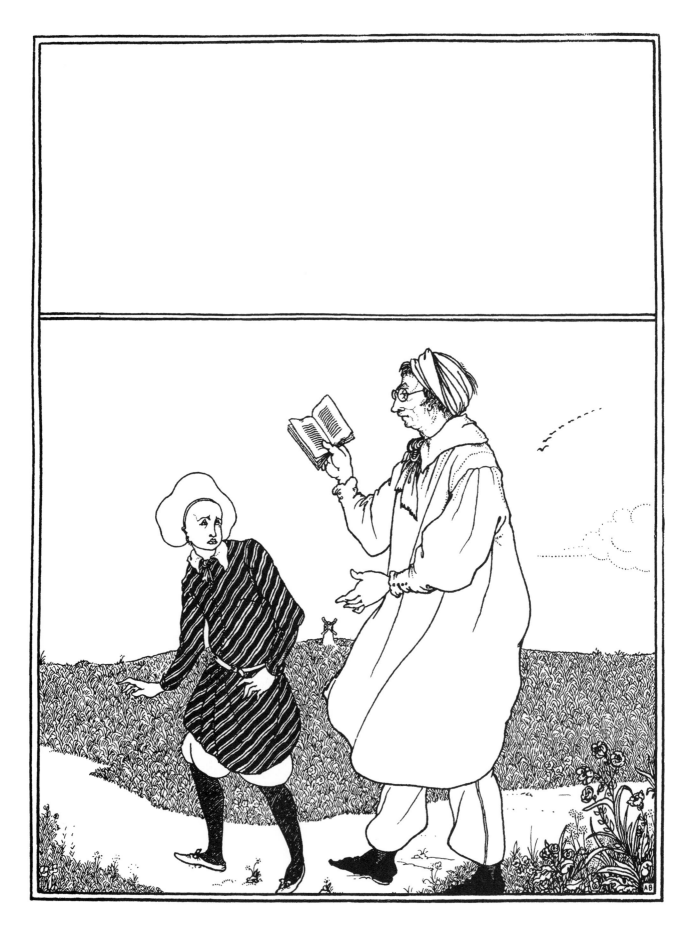

Cover design from *The Savoy*, No. 7, November 1896.

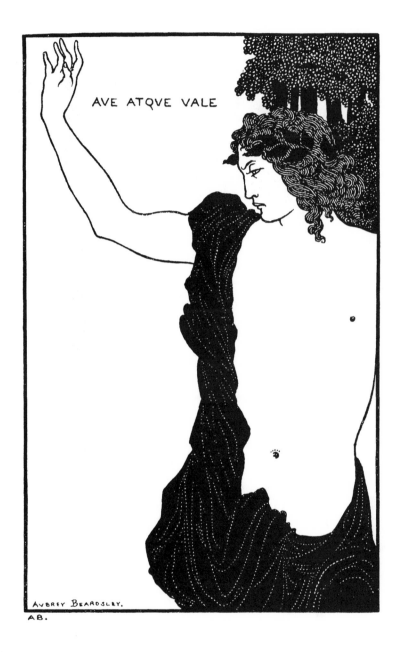

AVE ATQVE VALE

AVBREY BEARDSLEY.
AB.

"Ave Atque Vale," illustrating Beardsley's translation
of Catullus's "Carmen CI" that appeared in *The Savoy*,
No. 7. The Latin reads: "Hail and farewell."

Cover design from *The Savoy*, No. 8, December 1896.

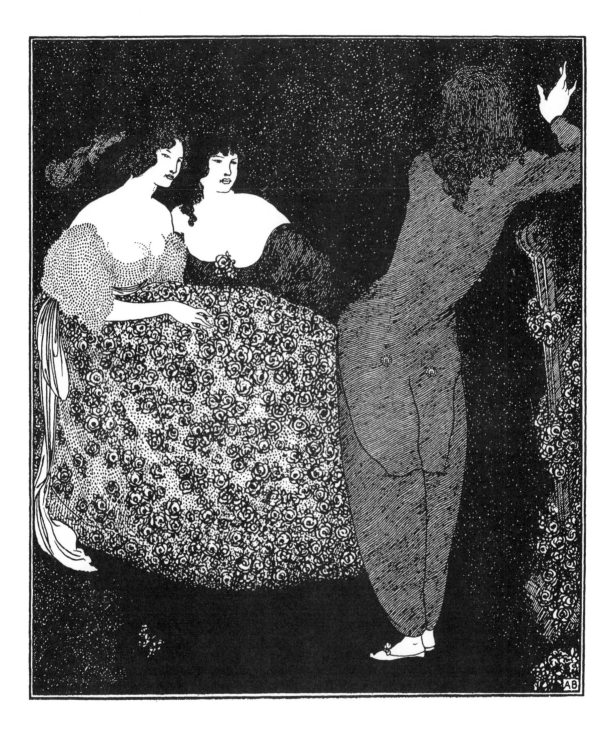

"A Répétition of Tristan und Isolde," from *The Savoy,*
No. 8.

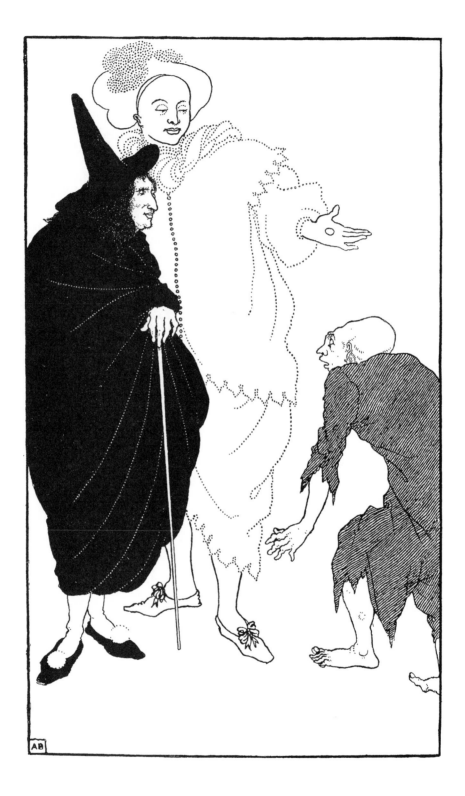

"Don Juan, Sganarelle, and the Beggar," from *The Savoy*, No. 8. These are characters in Molière's *Don Juan*.

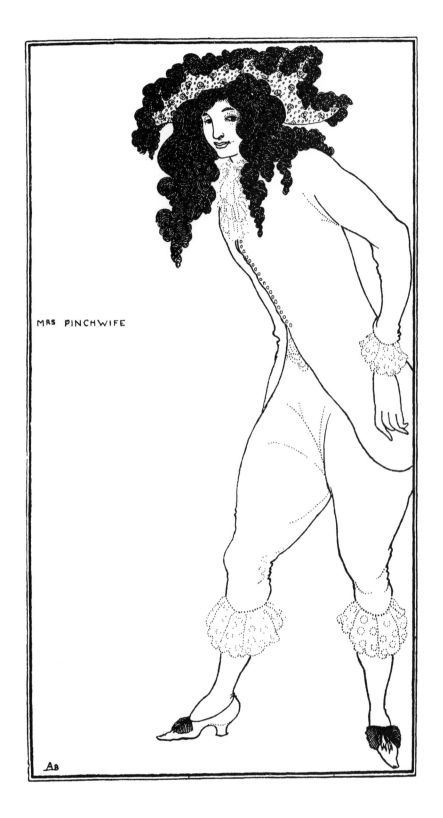

MRS PINCHWIFE

"Mrs. Pinchwife," from *The Savoy*, No. 8. Mrs.
Pinchwife is a character in William Wycherley's
comedy *The Country-Wife*.

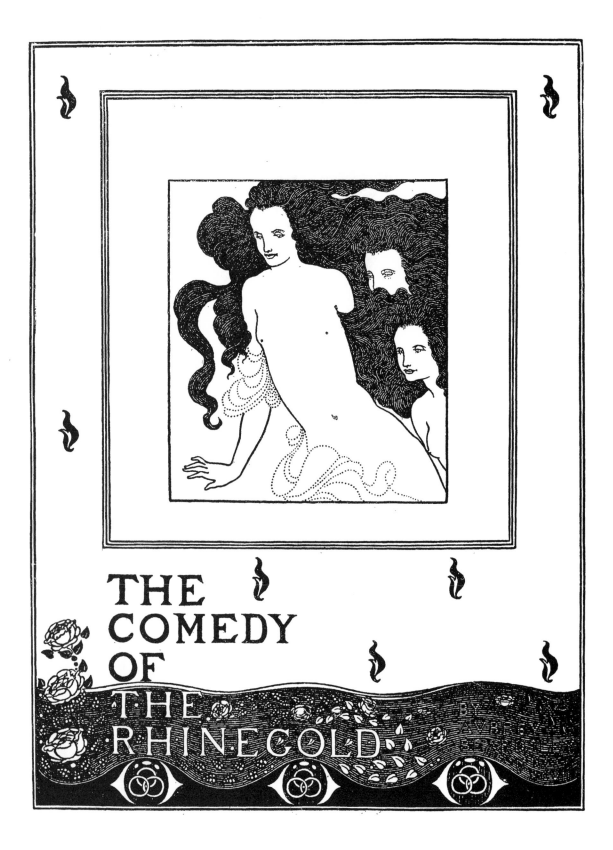

"Frontispiece to The Comedy of the Rhinegold," from
The Savoy, No. 8. Beardsley once proposed to write a
comedy, based on *Das Rheingold*, entitled *The
Comedy of the Rhinegold*. Notice his "byline" in the
lower right-hand corner of the illustration.

ALBERICH

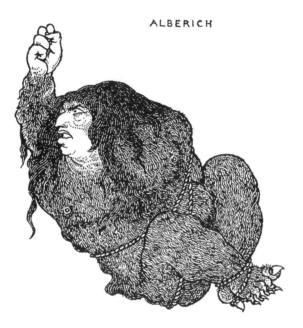

"Alberich," from *The Savoy,* No. 8. Alberich is a
character in *Das Rheingold.*

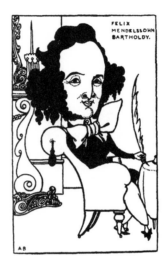

"Felix Mendelssohn Bartholdy," a caricature from *The Savoy*, No. 8.

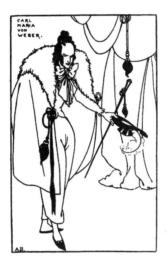

"Carl Maria von Weber," a caricature from *The Savoy*, No. 8.

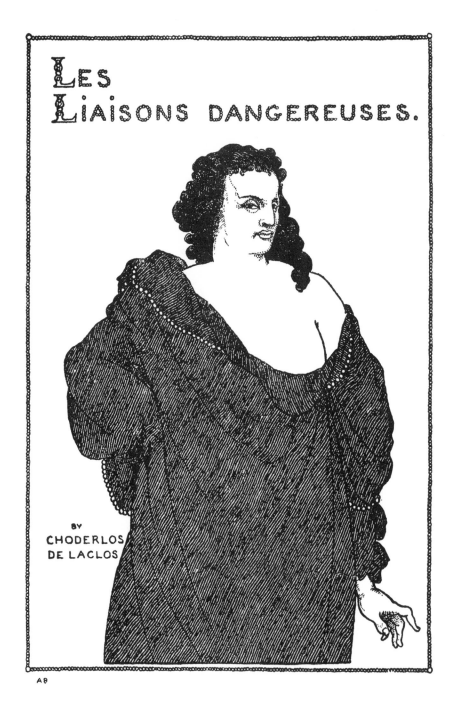

"Count Valmont," a proposed title page for Pierre
Choderlos de Laclos's *Les Liaisons Dangereuses,* from
The Savoy, No. 8.

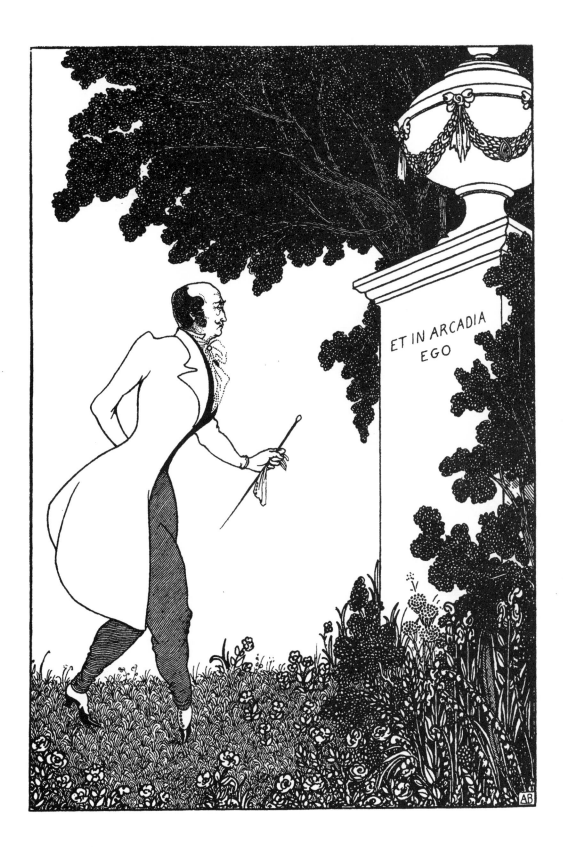

"Et in Arcadia Ego," an illustration accompanying an announcement in *The Savoy,* No. 8 of the magazine's discontinuation. The phrase "Et in Arcadia Ego" was a pun on the publisher's address, the Royal Arcade in London.

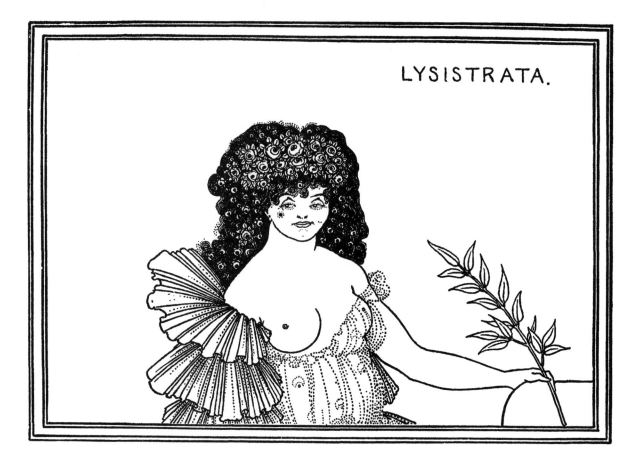

"Lysistrata" (expurgated version), from *The Lysistrata
of Aristophanes,* published in a limited edition by
Leonard Smithers, London, 1897.

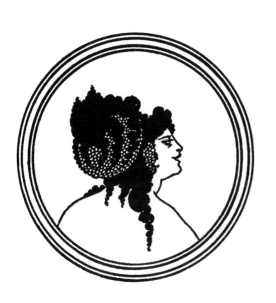

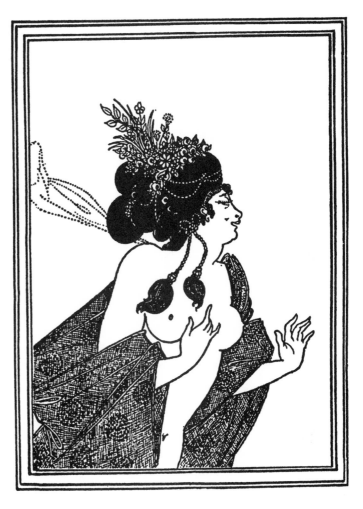

Lampito. Detail of "The Toilet of Lampito," from *Lysistrata.*

Myrrhina. Detail of "Cineseas Soliciting Myrrhina," from *Lysistrata.*

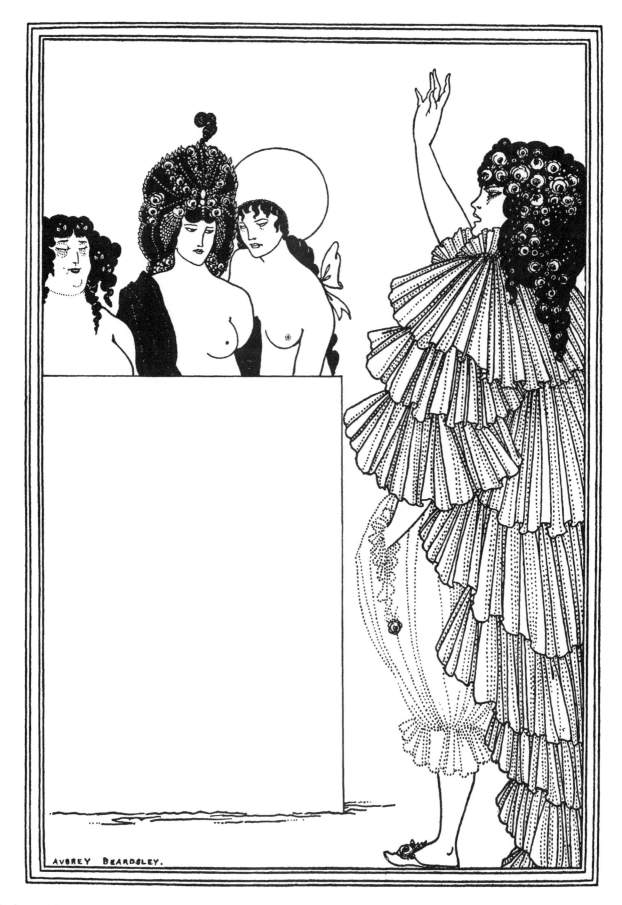

"Lysistrata Haranguing the Athenian Women"
(expurgated version), from *Lysistrata*.

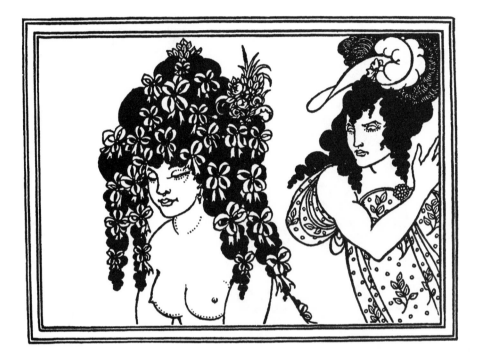

Detail of "Lysistrata Defending the Acropolis," from
Lysistrata.

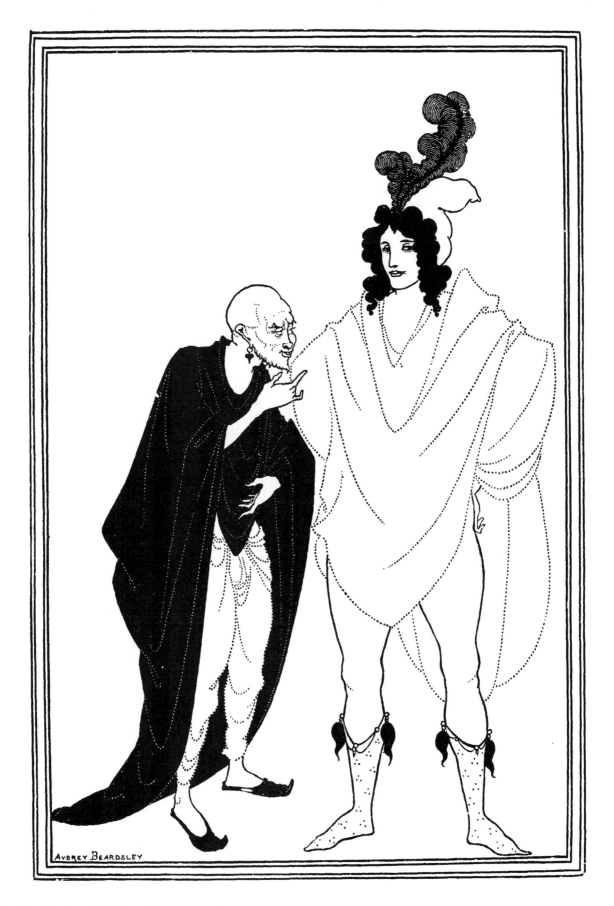

"The Examination of the Herald" (expurgated
version), from *Lysistrata.*

112

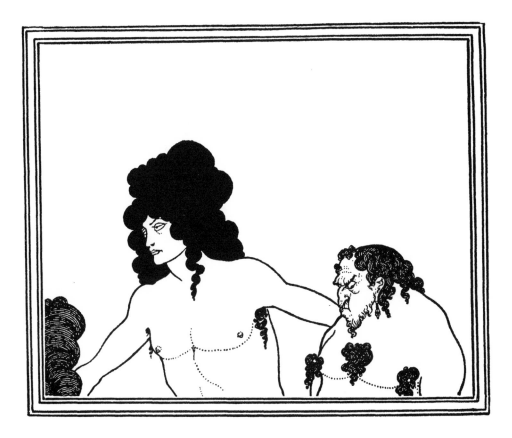

Detail of "The Lacedaemonian Ambassadors," from
Lysistrata.

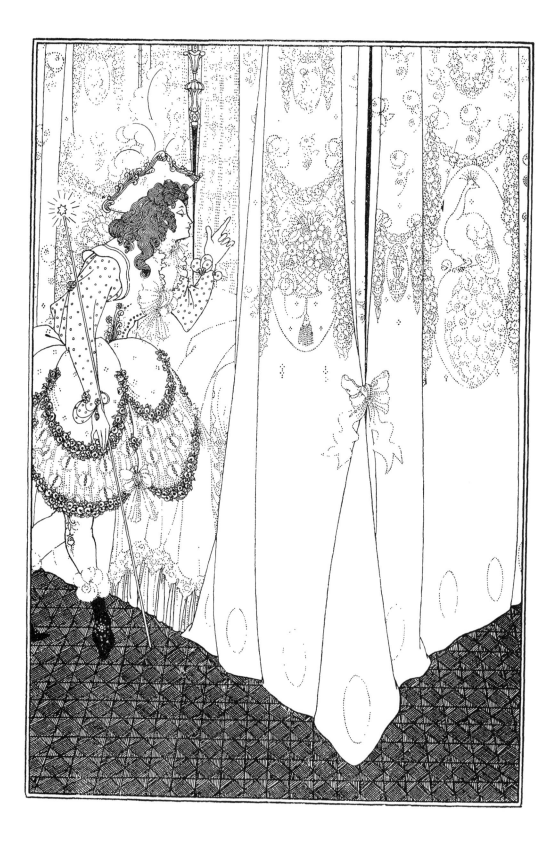

"The Dream," from *The Rape of the Lock* by
Alexander Pope, published by Leonard Smithers,
London, 1896.

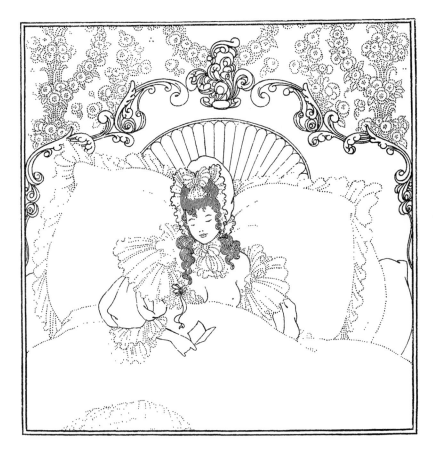

"The Billet-Doux," from *The Rape of the Lock.*

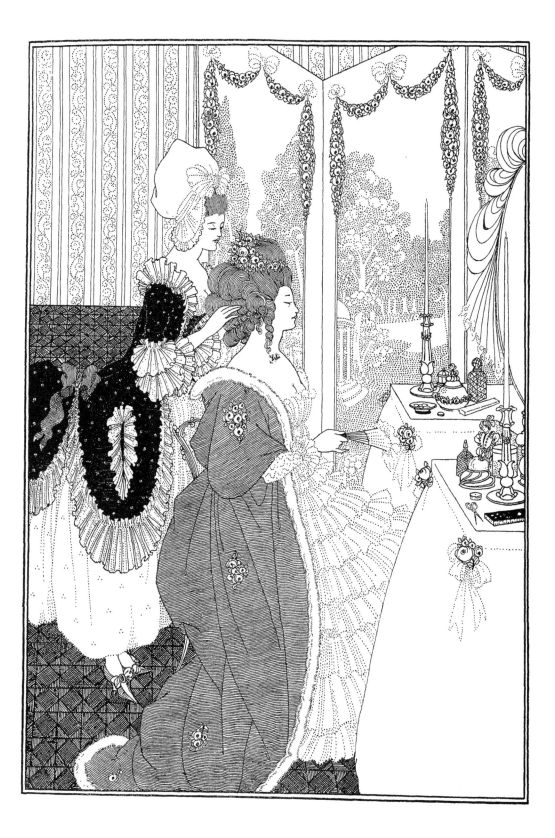

"The Toilet," from *The Rape of the Lock.*

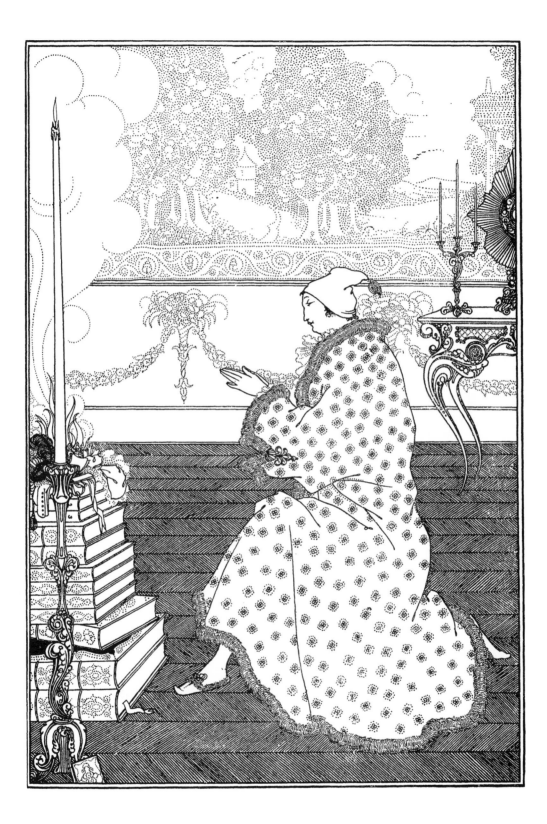

"The Baron's Prayer," from *The Rape of the Lock.*

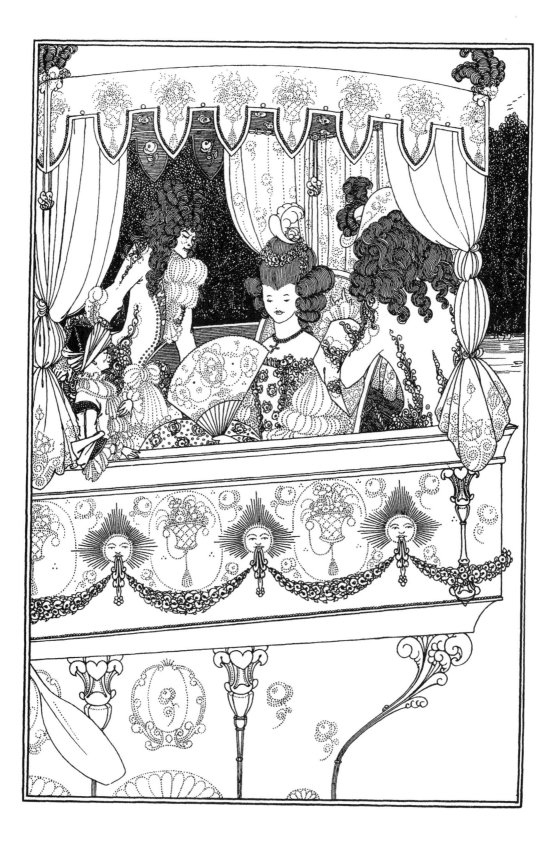

"The Barge," from *The Rape of the Lock.*

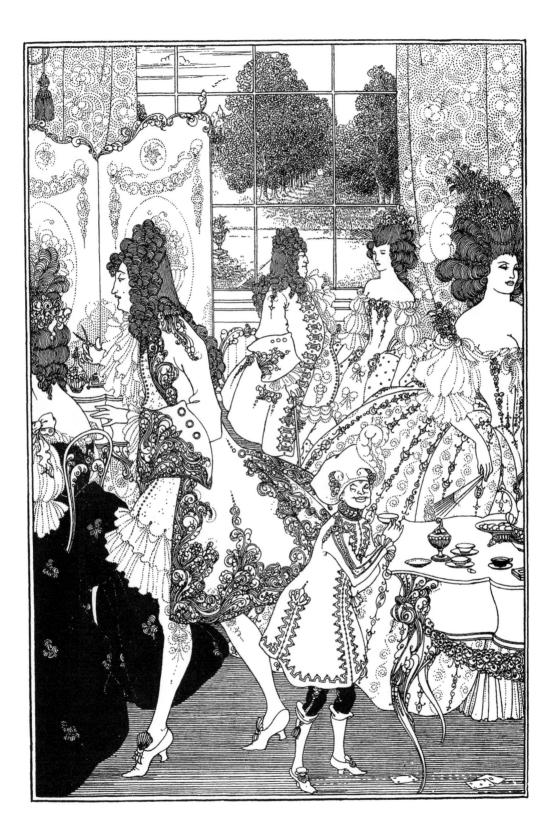

"The Rape of the Lock." This drawing appeared in
The Savoy, No. 2, as well as in *The Rape of the Lock.*

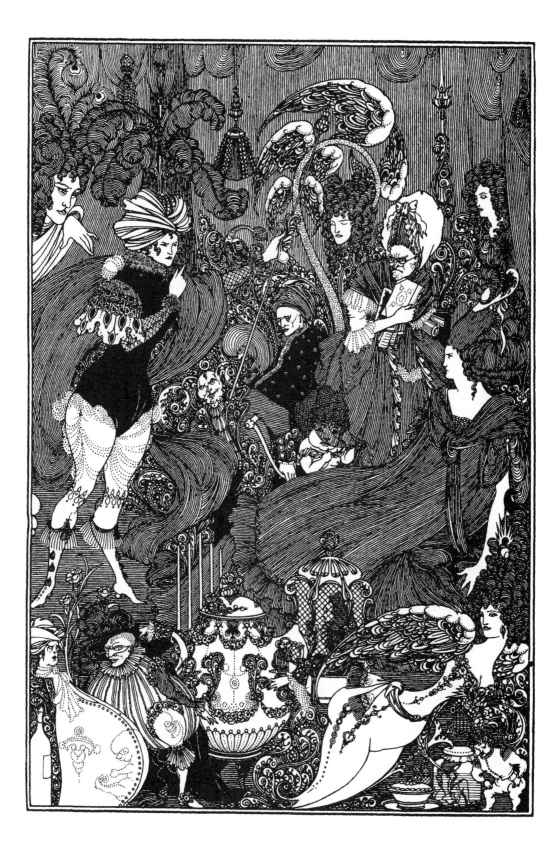

"The Cave of Spleen," from *The Rape of the Lock.*

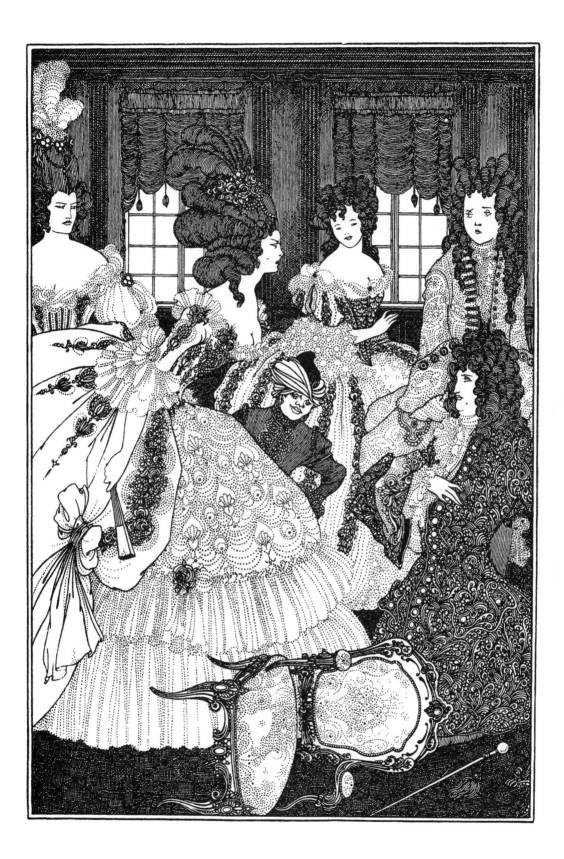

"The Battle of the Beaux and the Belles," from *The Rape of the Lock*.

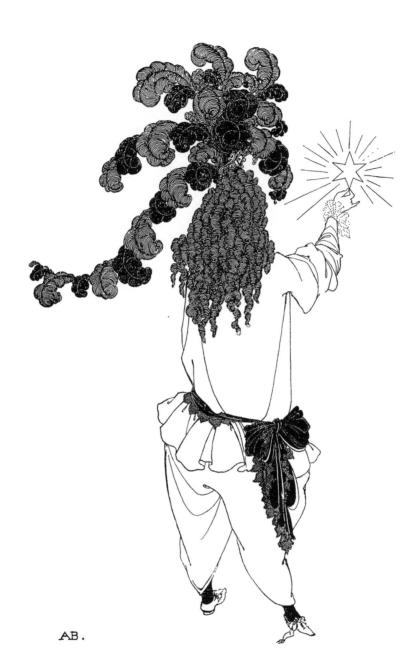

"The New Star," tailpiece to *The Rape of the Lock.*

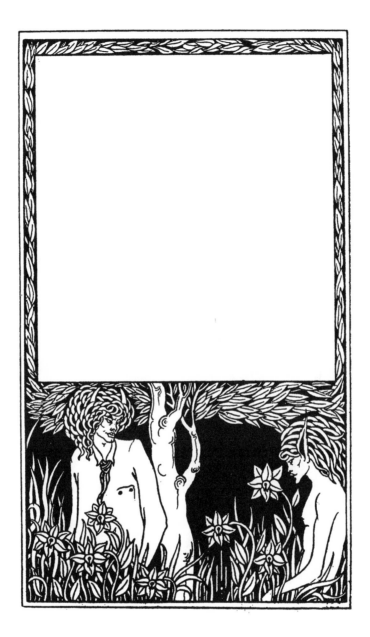

Title-page design from *Pagan Papers* by Kenneth
Grahame, published by John Lane, London, 1893.

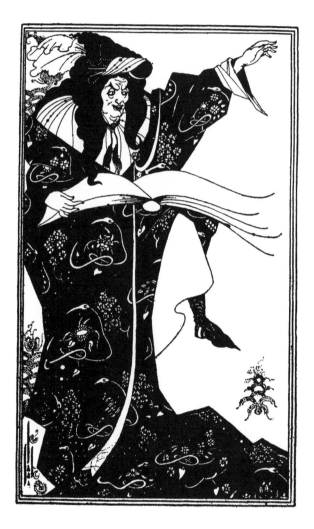

Frontispiece to *Virgilius the Sorcerer,* published by
David Nutt, London, 1893.

124

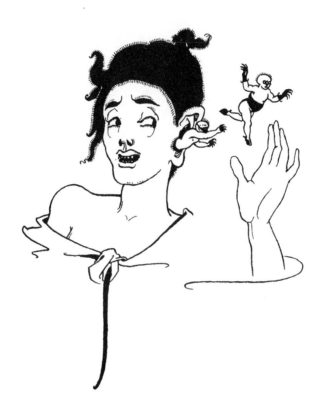

Design for the "Bon Mots" series published by J. M.
Dent & Co., London, 1893–94.

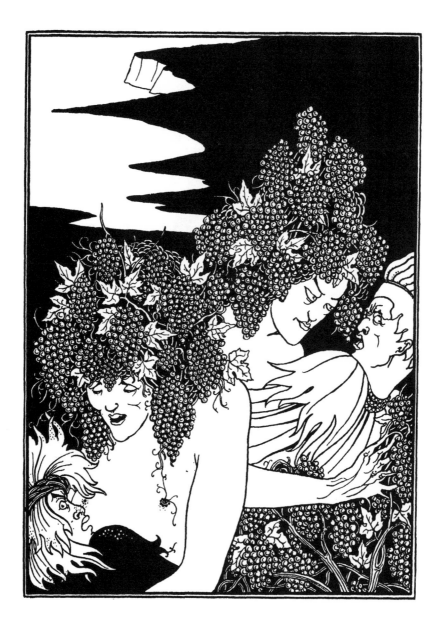

"The Snare of Vintage," from *Lucian's True History,*
published by Lawrence & Bullen, London, 1894.

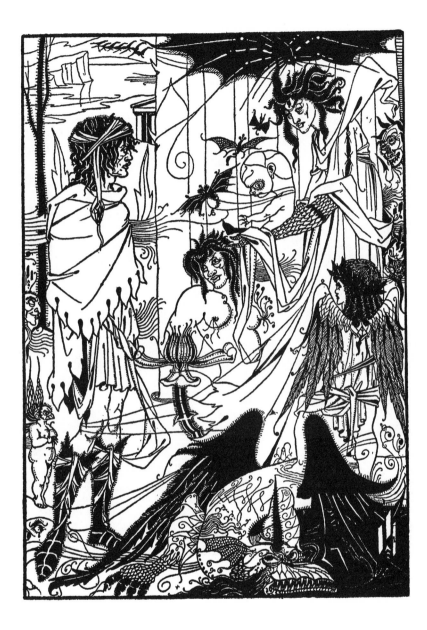

"Dreams," from *Lucian's True History*, 1894.

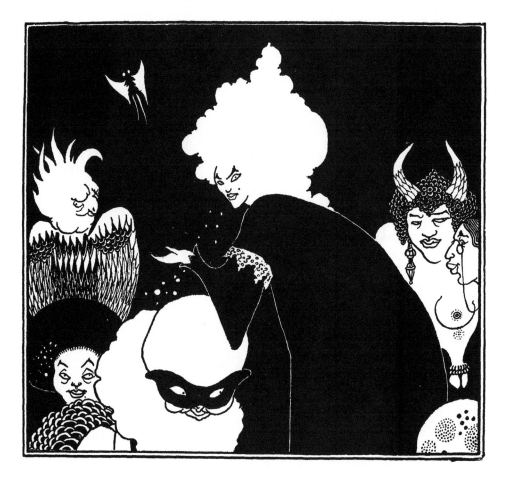

"Lucian's Strange Creatures" (expurgated version),
1894. Intended for *Lucian's True History* but not
published therein.

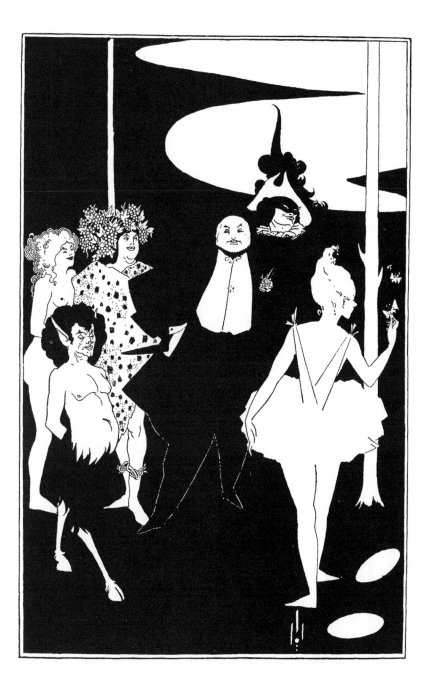

Frontispiece to *Plays* by John Davidson, published by
Elkin Mathews and John Lane, 1894.

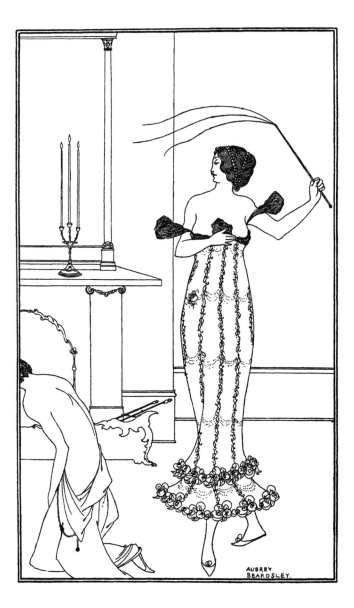

Frontispiece to *Earl Lavender,* published by Ward &
Downey, London, 1895.

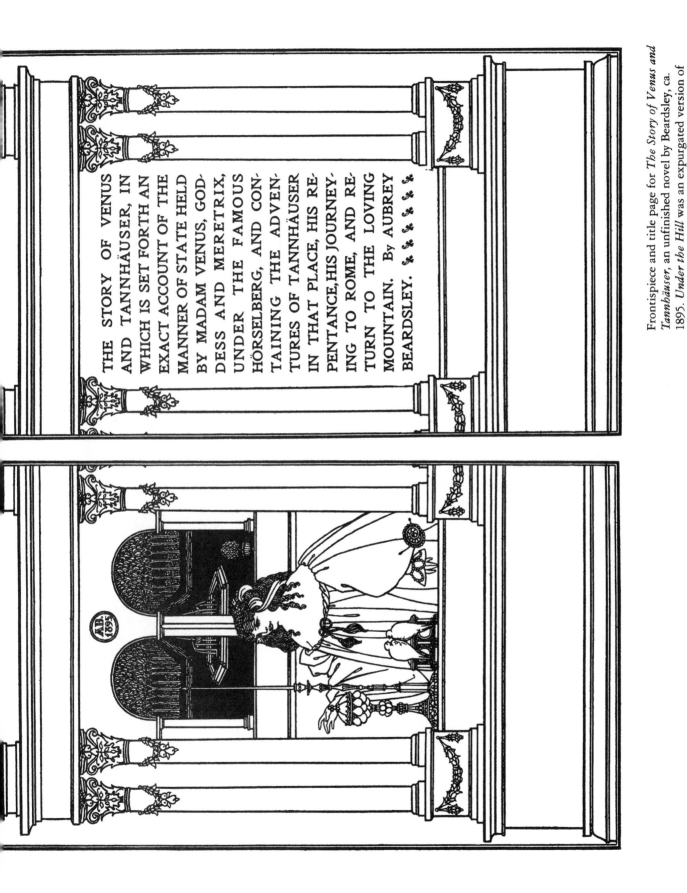

THE STORY OF VENUS AND TANNHÄUSER, IN WHICH IS SET FORTH AN EXACT ACCOUNT OF THE MANNER OF STATE HELD BY MADAM VENUS, GODDESS AND MERETRIX, UNDER THE FAMOUS HÖRSELBERG, AND CONTAINING THE ADVENTURES OF TANNHÄUSER IN THAT PLACE, HIS REPENTANCE, HIS JOURNEYING TO ROME, AND RETURN TO THE LOVING MOUNTAIN. By AUBREY BEARDSLEY.

Frontispiece and title page for *The Story of Venus and Tannhäuser*, an unfinished novel by Beardsley, ca. 1895. *Under the Hill* was an expurgated version of this novel.

131

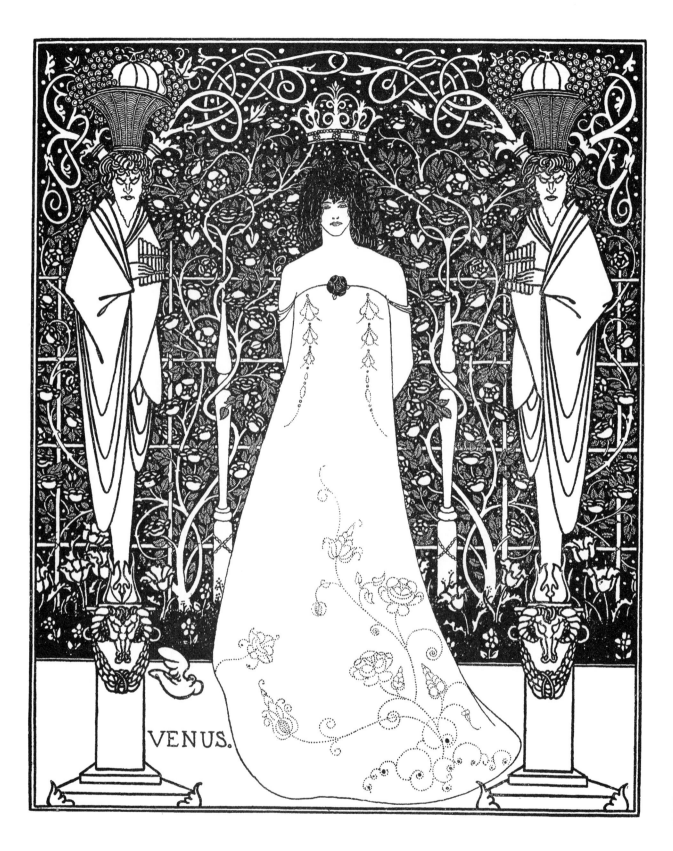

Frontispiece design for *The Story of Venus and Tannhäuser.*

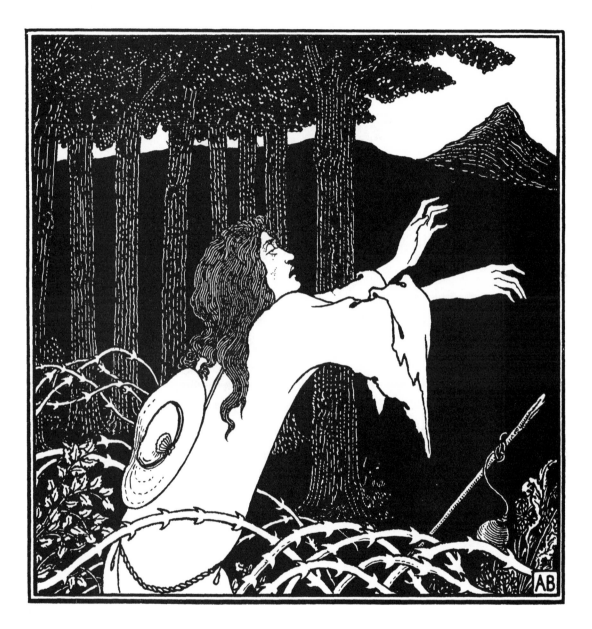

"The Return of Tannhäuser to Venusberg," for *The Story of Venus and Tannhäuser.*

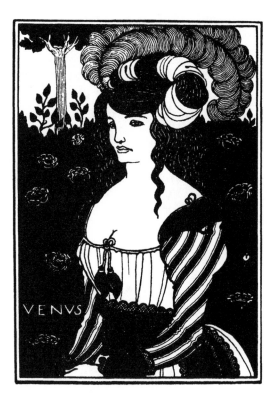

"Venus," for *The Story of Venus and Tannhäuser.*

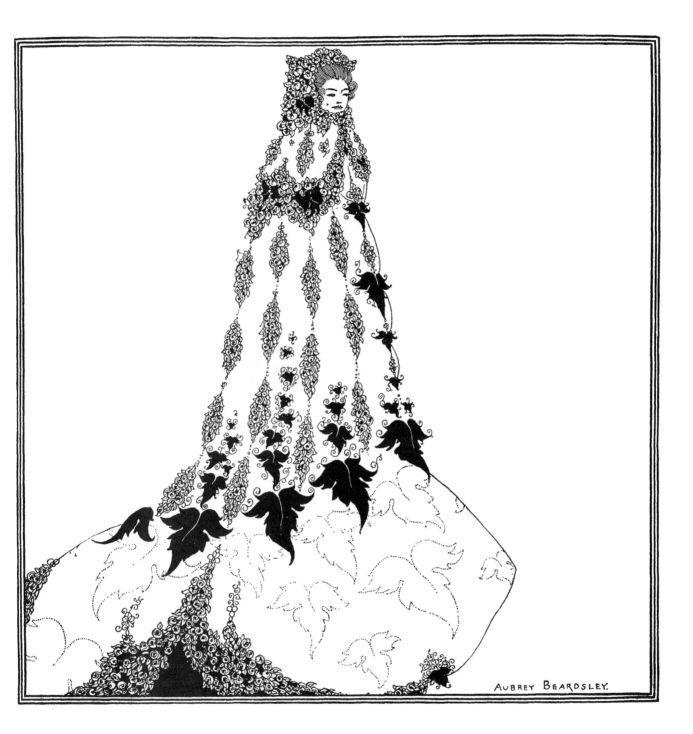

"A Suggested Reform in Ballet Costume," illustrating
the poem "At a Distance" by Justin McCarthy, 1895.

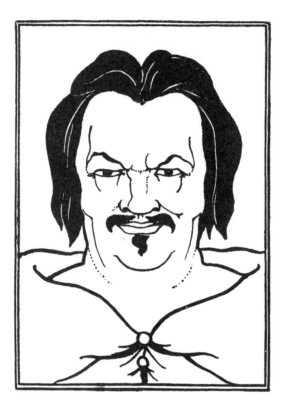

Cover design for Balzac's *La Comédie Humaine*, ca.
1895.

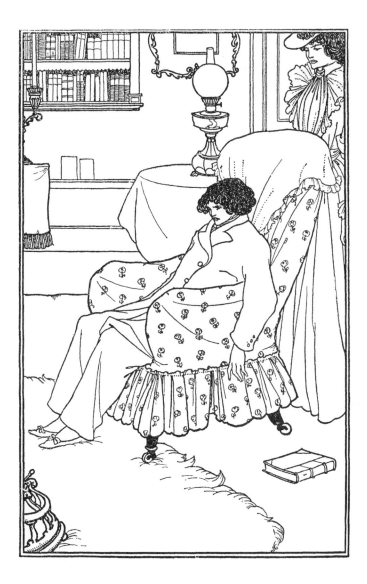

Frontispiece to *An Evil Motherhood* by Walt Ruding,
published by Elkin Mathews, 1896.

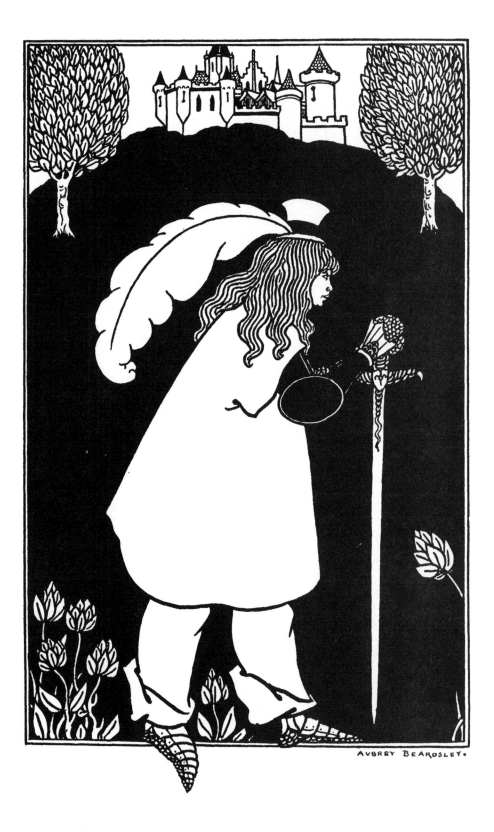

Illustration from *Baron Verdigris* by Jocelyn Quilp,
published by Henry & Co., London, 1896.

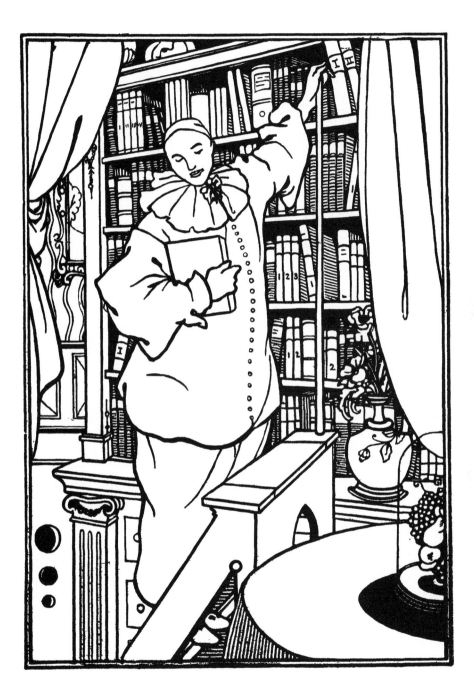

Cover design from "Pierrot's Library," a series
published by John Lane, 1896.

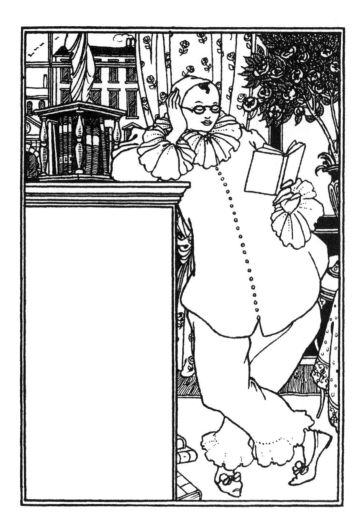

Title-page design from the "Pierrot's Library" series,
1896.

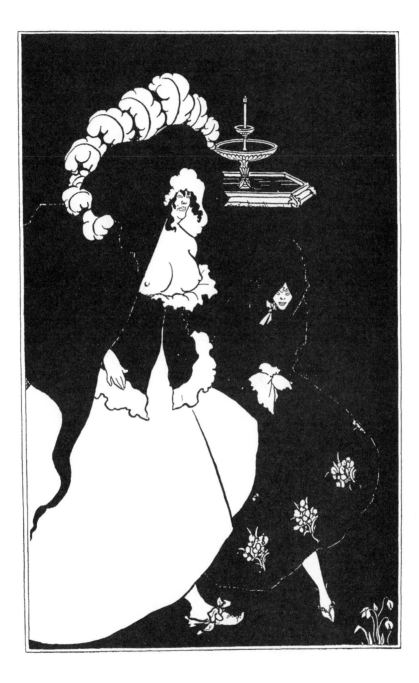

"Messalina Returning Home," for *The Sixth Satire of Juvenal*, 1895.

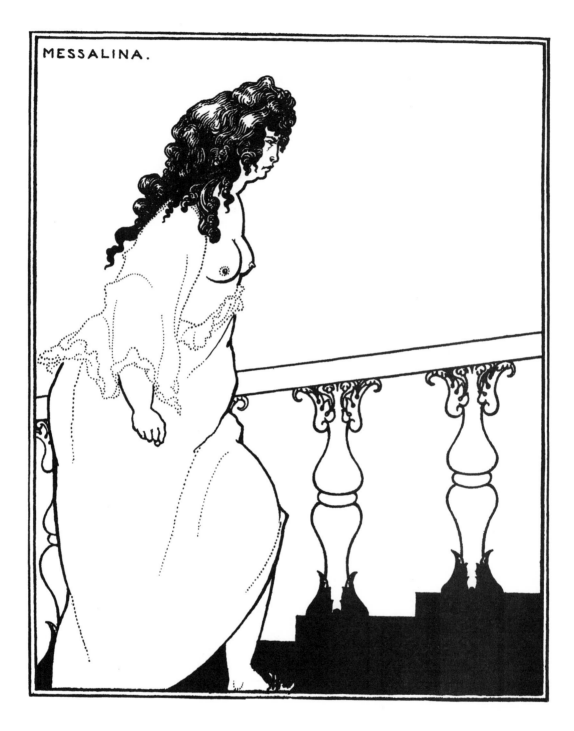

"Messalina Returning from the Bath," for *The Sixth
Satire of Juvenal*, 1897.

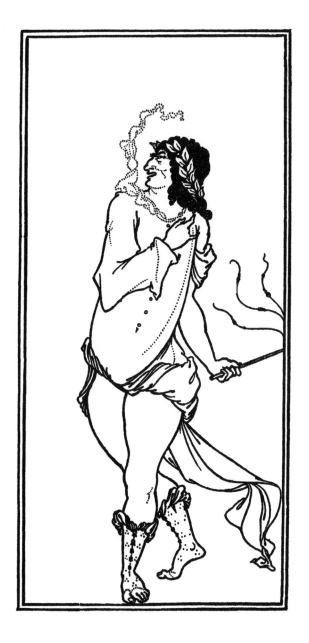

Expurgated detail of "Juvenal Scourging Woman," for
The Sixth Satire of Juvenal, 1897.

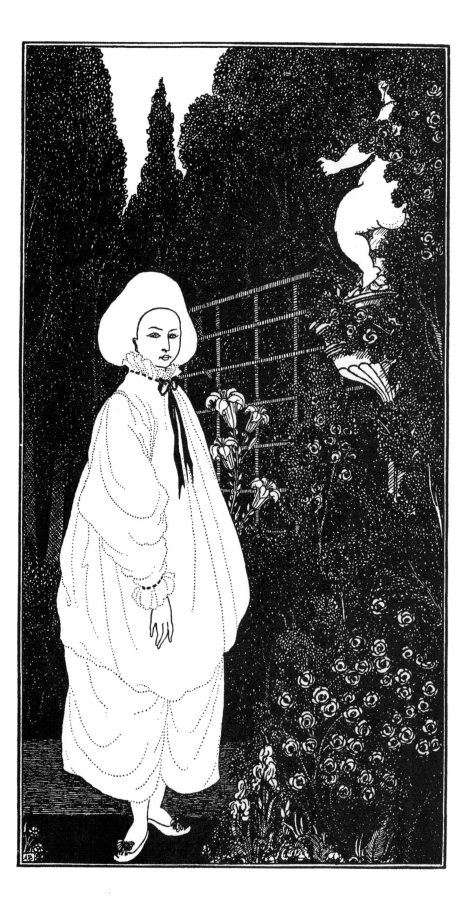

Frontispiece to *Pierrot of the Minute* by Ernest
Dowson, published by Leonard Smithers, 1897.

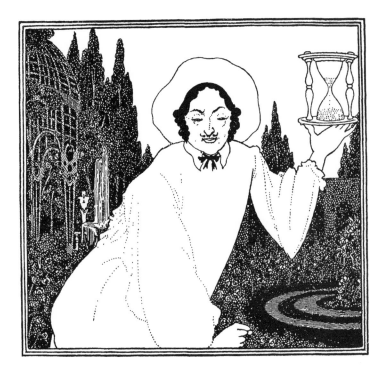

Headpiece from *Pierrot of the Minute.*

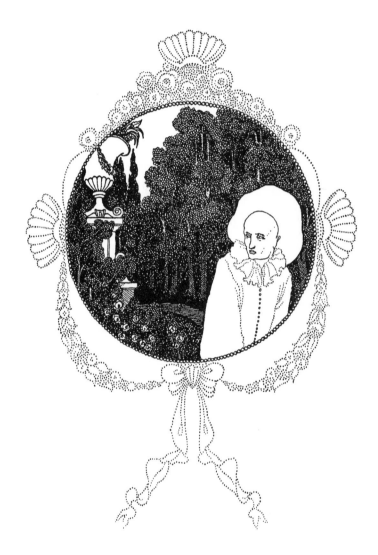

Cul-de-Lampe from *Pierrot of the Minute.*

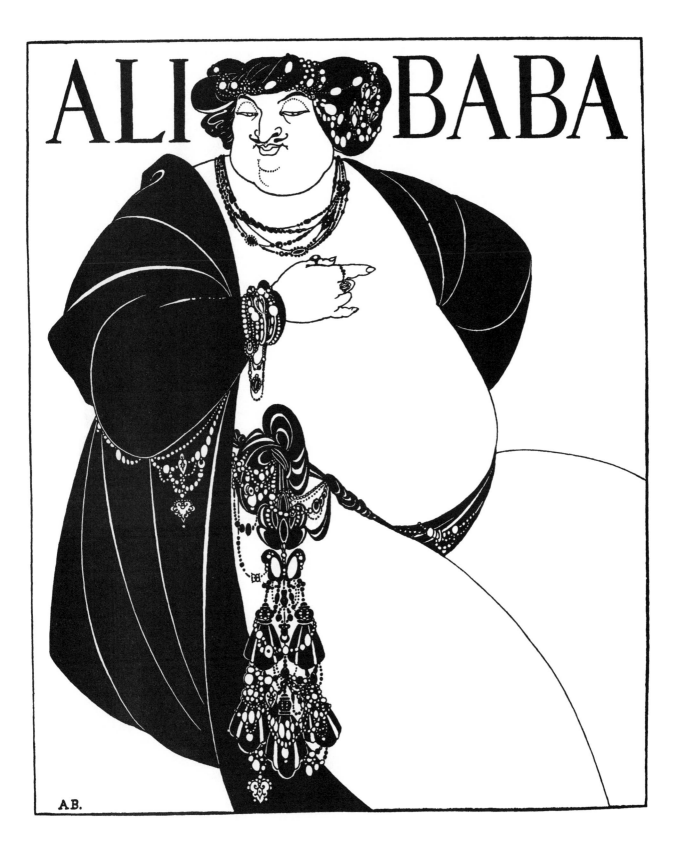

Cover design for *The Forty Thieves*, 1897. An edition
of this book was projected by Smithers during
Beardsley's lifetime but not published.

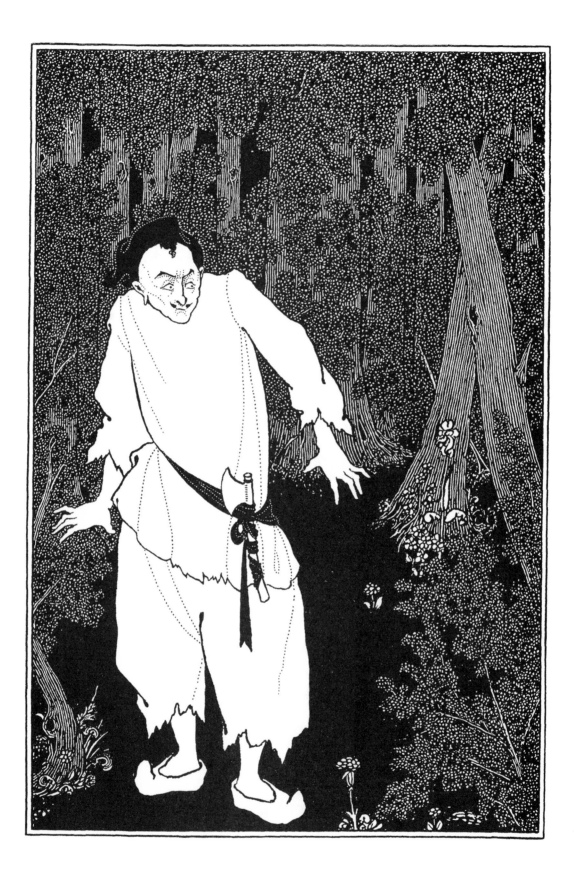

"Ali Baba in the Wood," for *The Forty Thieves*.

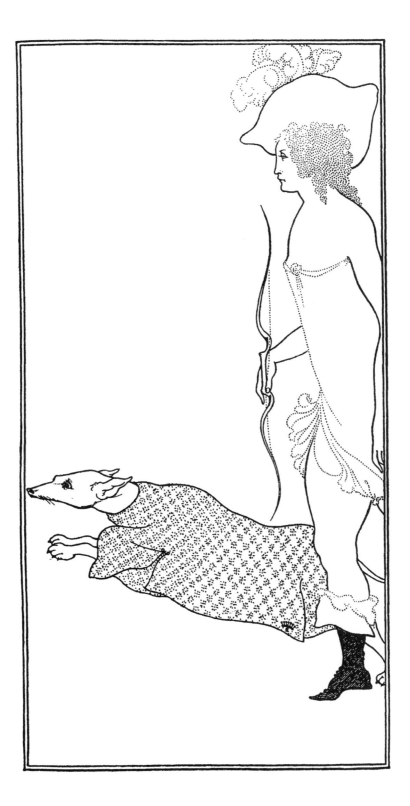

"Atalanta in Calydon," for Algernon Charles
Swinburne's work of the same name, 1897.

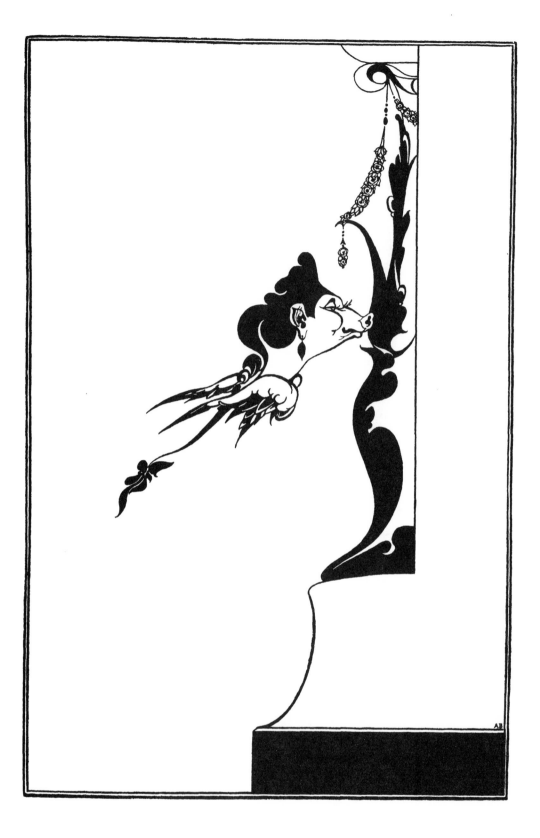

Cover design from *The Houses of Sin* by Vincent
O'Sullivan, published by Leonard Smithers, 1897.

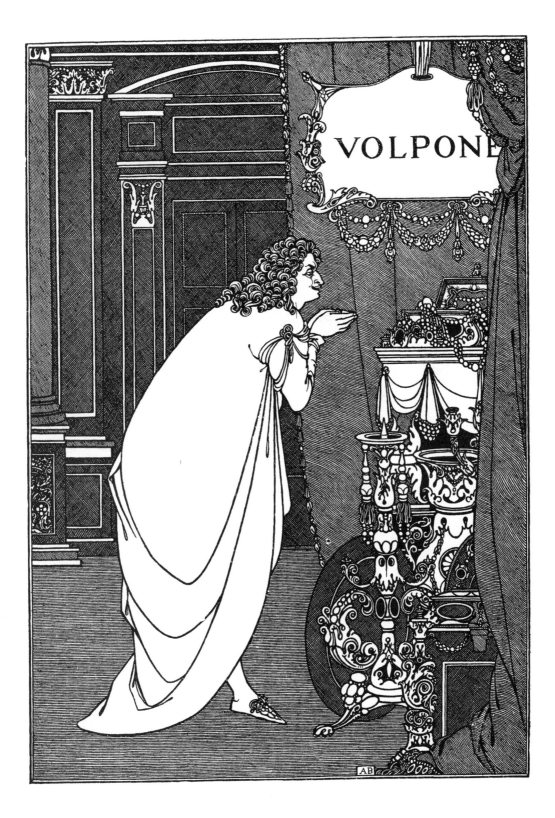

"Volpone Adoring His Treasure," frontispiece to Ben Jonson's *Volpone,* published by Leonard Smithers, 1898.

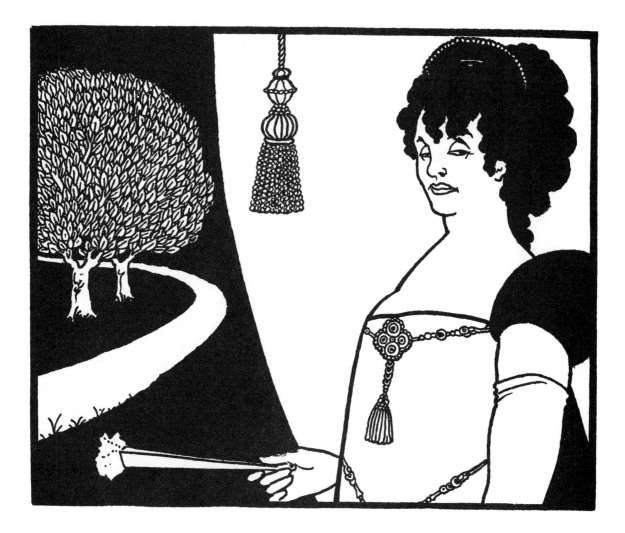

"Madame Réjane," 1893. This was one of several
caricatures Beardsley executed of the celebrated French
actress, whom he knew personally.

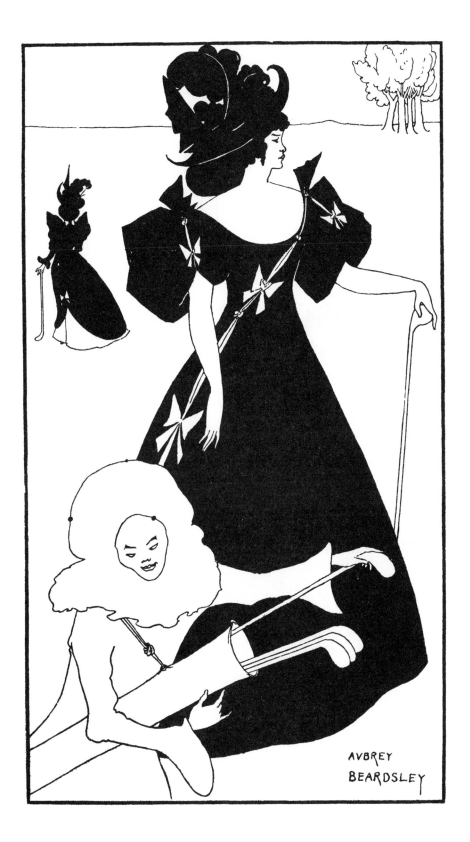

Invitation card to the opening of the Prince's Ladies
Gold Club at Mitcham, Surrey, 1894.

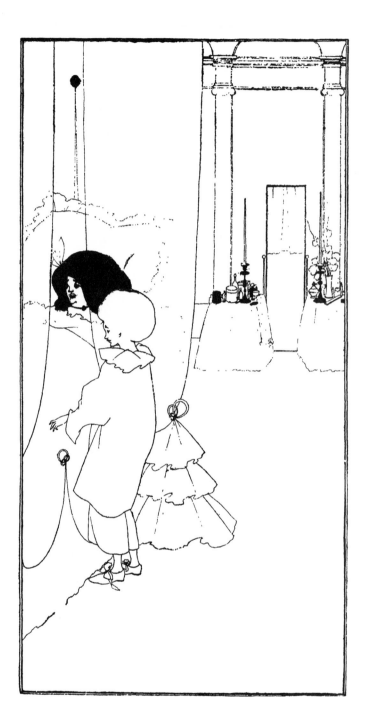

"A Child at Its Mother's Bed," 1895.

154

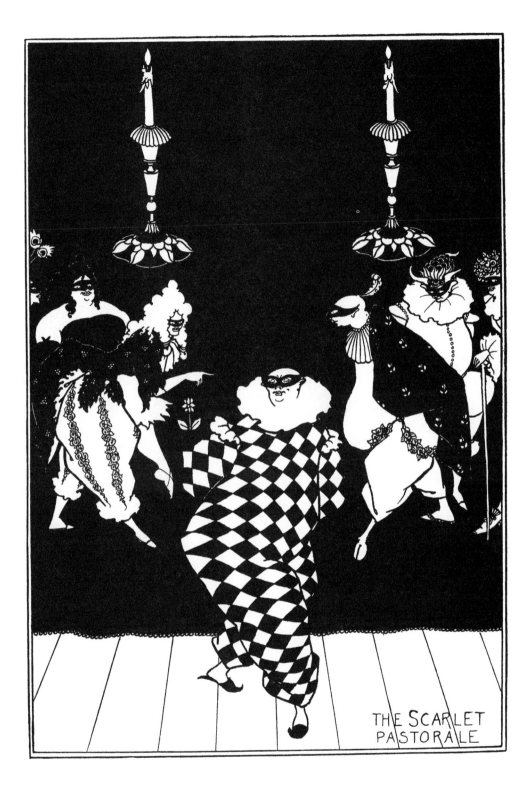

"The Scarlet Pastorale," 1895.

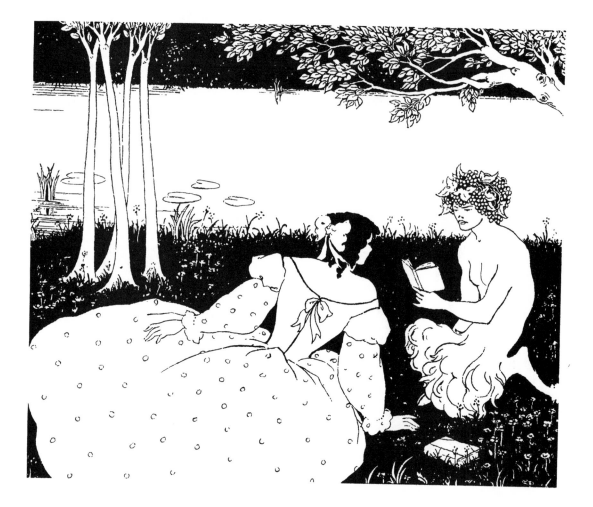

Cover design, 1895.

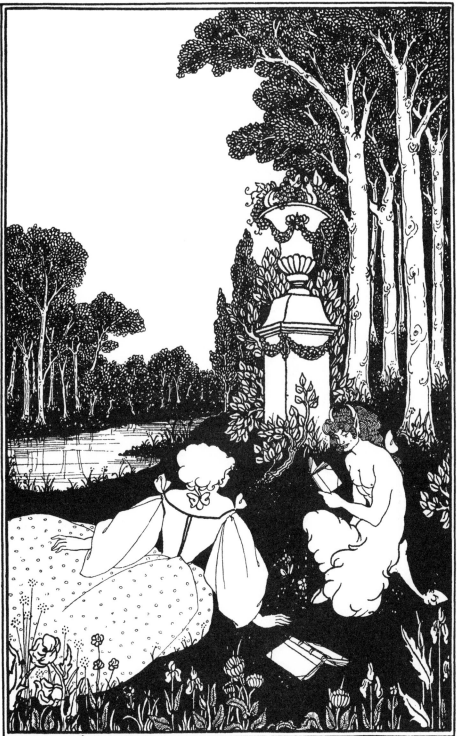

Cover design for a catalogue, 1895.

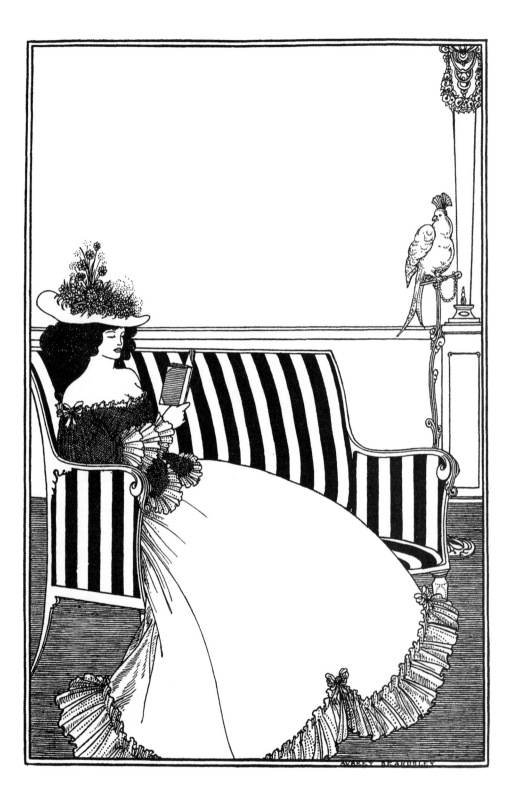

Cover design from Smithers' Fifth Catalogue of Rare
Books, 1896.

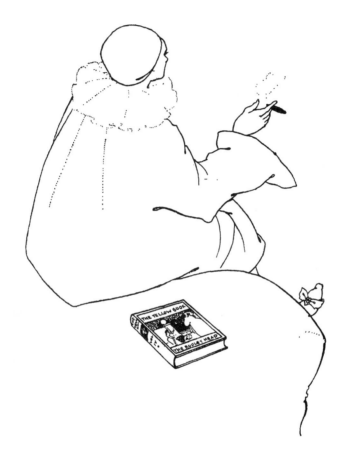

Design for an invitation card.

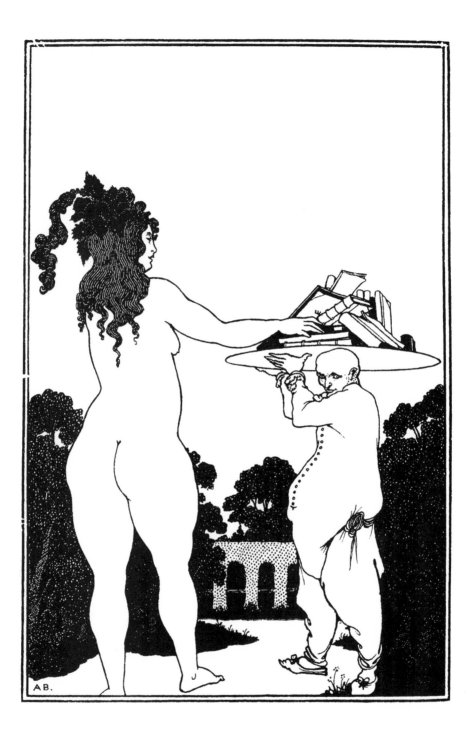

"Aubrey Beardsley's Book-Plate," 1897. Though this is
known as "Aubrey Beardsley's Book-Plate," it was
allegedly not used by him.